THOMAS KINKADE
HEAVEN ON EARTH

JEFFREY VALLANCE

MBNA America Credit Card
Embossed plastic with screen print
MBNA America
www.mbna.com

GRAND CENTRAL PRESS
Santa Ana, California

LAST GASP
San Francisco, California

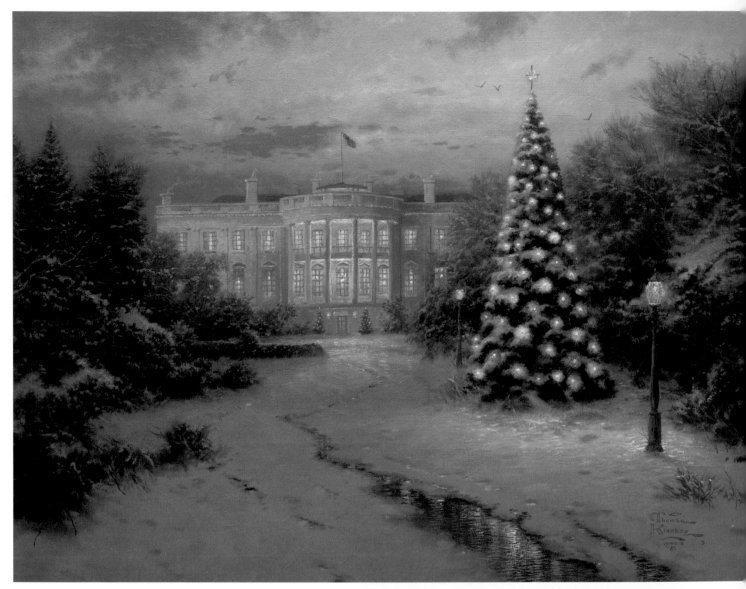

The Lights of Liberty, 2000
Season of Lights Series
Oil on canvas, 16 x 20
Collection of Thomas Kinkade
Courtesy of the Thomas Kinkade Museum
and the Thomas Kinkade Company
Published: September 2000

Each year, the Christmas Tree Foundation selects one artist
to render a painting of the large Christmas tree in
Washington D.C. Thom was chosen to be the official artist
of the year 2000. Not only did Thom paint the tree, but
also included the Presidential White House. He said it is
not so much a "political painting", but it is a tribute to "the
American System." Thom presented a lithograph of this
image last year to the former first family, Bill and Hillary
Clinton (right).

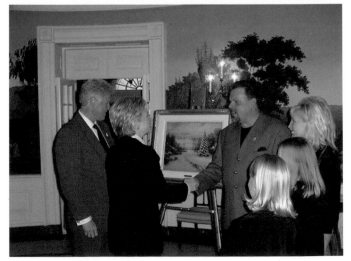

Wallpaper detail
Pre-pasted peelable vinyl
Thomas Kinkade Painter of Light Volume 2
Imperial Wall Décor
© Imperial
www.ihdg.com

Andrea Lee Harris, Director
CSUF Grand Central Art Center

Thomas Kinkade: Heaven on Earth is an exhibition that evolved out of a conversation. The Grand Central Art Forum, known for developing projects that challenge conventional notions and for providing a platform for vivacious and varied aspects of American culture, was intrigued by the art of Thomas Kinkade. What was it about the idyllic images of peace, love, and tranquility that either made one's heart leap with desire or beat with disdain? Partnering with guest curator Jeffrey Vallance, CSUF Grand Central Art Center, Grand Central Art Forum, and CSUF Main Gallery decided to take on arguably the most commercially successful artist in America and examine what engendered such radical personal reactions to "The Painter of Light."™

Jeffrey Vallance's vision of a broad exploration of Kinkade's work, ranging from originals to every kind of collectible, is the most in-depth survey of Kinkade's work ever assembled in a contemporary art space. The combination of CSUF Grand Central Art Center and CSUF Main Gallery is an appropriate fit for *Thomas Kinkade: Heaven on Earth* because, while the CSUF Main Gallery has consistently developed scholarly contributions to contemporary visual culture for more than forty years, the Grand Central Art Center, in the five years since it was founded, has developed a reputation for examining the fringes of Contemporary art.

There are many who have been touched by the light and have made this exhibition and publication a reality. We would first like to thank guest curator Jeffrey Vallance for his vision, guidance, and commitment to this exhibition. To Thomas Kinkade and his family we offer our appreciation for making this project possible, and we send many thanks to Rick and Terri Polm and Mary Ann Kinkade for lending precious original paintings to this exhibition. Thanks to the writers, Jeffrey Vallance, Ralph Rugoff, Doug Harvey, Reverend Ethan Acres, Mike McGee, and Thomas Kinkade, whose essay contributions illuminated this publication and brought the exhibition to life. For their support and encouragement of this publication, we thank The Thomas Kinkade Company (formally Media Arts Group, Inc.) especially Lynn Hoffman-Luce and Jim Bryant, Bob Davis of the Thomas Kinkade Foundation and Vu Myers of the Thomas Kinkade Museum; Gary Kornblau at *Art issues;* and Ron Turner, Colin Turner and Bucky of Last Gasp Publishing. A special note of thanks goes to the Grand Central Art Forum members who conceived of this project—Don Cribb, Mitchell DeJarnett, Greg Escalante, John Gunnin, Shelley Liberto, and Stuart Spence—and to the other board members for their continued support of this and other projects.

Our thanks to staff and significant contributors to this project, including Amy Caterina-Barrett, Brett Caterina-Barrett, Rebecca C. Banghart, Debora Brown, Marty Lorigan,

Lamplight Bowl
Porcelain
Gallery Marketing Group Inc.
www.gallerymarketinggroup.com

Jason Chakravarty, Edgar M. Tellez, Dennis Cubbage, Bree Cubbage, Bill Dickerson, James Lorigan, Alexander James Harris, Sue Henger, Scott Hilton, Larry Johnson, Eric Jones, David Michael Lee, Marilyn Moore, Mable P. Reed, Jerry Samuelson, Frank Swann, Lorraine Waters, Art Alliance, Exhibition Design Students, and all the supportive staff at CSUF and CSUF Foundation.

We also extend our appreciation to the many companies who are licensees of Kinkade imagery and collectibles and their helpful staff members who contributed to this publication and the exhibition: R.G. Micka, Annett Kiebler, Barry Kadische, Josh Walls and Mike Rowley of La-Z-Boy Inc.; Kelly Ann Colgan and Nancy Parker of Gallery Marketing Group; Neil Paladino of Bloomcraft; Harris Sterling and Amanda Lees of Madacy Entertainment; Gus Walbute and Kelly Baily of Medco/Amcat; Jim and Margie Behrings of Behrings Art Care; Beverly Watson, Kathy Baker and Dana Long of Thomas Nelson Publishing; Deborah Portuges and Steve Gordon of William Hezmalhalch Architects Inc.; Taylor Woodrow Homes; Neil Martin and Jenn Breslow of The Advanced Group Inc.; Tommi Jamison of Hearthstone Inc.; Mohawk Homes Goodwin Weavers; Tony Sousa of Ceaco Inc.; Jay Haws and Ed Dudley of Rocky Mountain Chocolate Factory; Monika Brandup-Hauge of Pop Shots; Enrique Tarron of Splendor Lighting; Imperial Wall Décor; Tami Richardson of Brownlow Corp.; Judy Swetish of Candamar Designs; Betsy Stuart of Elm Puzzles; Teleflora; Matthew Ballast of Warner Book Publishing Company; Jamie Schilling of MBNA America; Carl Perona of Frazee Paint Inc.; Nichole Bishop of Messenger Inc.; Andrea Borkes of Harvest House Books; Rita Shimleski, Denise Tully and Maryanne Geringwald of Lenox Inc.; Jackie Dickinson of Glass Master/OMNIA; Carrie A. Holmquist of Gregg Gift; Sandy Jones of USA Playing Cards; Village Gallery in Santa Ana, California.

End of a Perfect Day
A contented mind is the greatest blessing a man
can enjoy in this world. Joseph Adams
Woven pillow
Mohawk Homes Goodwin Weavers Collection
www.goodwinweavers.com

Jeffrey Vallance, Guest Curator

As an art professor I have observed for some years a certain phenomenon: in beginning drawing or painting classes, when I ask students to name living artists, they have a difficult time coming up with any. In the past, students could always invoke Warhol, but since his death, frequently the only name they come up with is Kinkade.

Artist Thomas Kinkade marks his life by a series of what he calls "miraculous coincidences." One such visionary event took place in 1980, when he was attending Art Center College of Design in Pasadena, California. Young Thomas had reached a state of disillusionment and skepticism. In an art class, he became disinterested in the nude model posing for the class, and he found his mind wandering. Suddenly, like a bolt of lightning, Thomas was struck with a powerful vision from God. Before him he beheld the miraculous face of Jesus. In a kind of religious ecstasy, he quickly painted his vision—what we now know as his portrait of Christ, *The Prince of Peace*. Kinkade's vision of the Savior is comparable to Veil of Veronica iconography. Experts in the study of Christian images claim that the Veronica (from vera + icon, meaning "true image") is related to the facial imprint on the Shroud of Turin. In 1992, I became familiar with Shroud imagery when I lived for a summer in a castle in Torino, Italy, researching the Holy Shroud of Turin. Kinkade's portrait of Jesus is strikingly similar to the Shroud image in a number of details: It is a frontal view of the head of Christ hovering on a sanguine-colored, stain-like background. Christ is bearded with long hair. His nose and cheeks are prominent. He wears the Crown of Thorns and His weary eyes are closed. Christ's face expresses deep sorrow, like that He experienced on the road to Calvary. A kind of spiritual light radiates from His face. God revealed Himself to Thomas that fateful day as the Light of the World—and the humble student was transformed into the Painter of Light™. ("I am the light of the world." John 8:12.)

According to his biography, "America's most collected artist" had a Tom Sawyer-like childhood in the Norman Rockwellesque hometown of Placerville, California. Famous now for his paintings of cozy cottages,

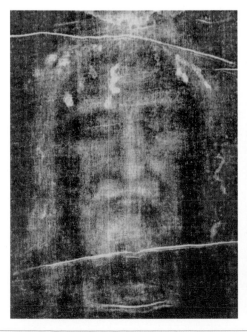 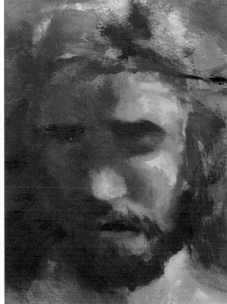

as a child Kinkade did not live in a cottage, but in a trailer park—in a mobile home filled with love. Many of Kinkade's cottages are based on actual homes in the English countryside or in the Austrian Alps. His cottages

Far left: Detail from the Shroud of Turin.
Left: Detail from Thomas Kinkade's *Prince of Peace*.

glow with a warm and fuzzy light, recalling a nostalgic, idyllic past—that never existed for him. For Kinkade, the light in his paintings "represents God's presence and influence." The Painter of Light™ warns us of the pitfalls of light deprivation. For three long years I lived in arctic Lapland, where winters are inconceivably cold and interminably dark. Like many people lacking sunlight, I became affected with S.A.D. (seasonal affective disorder), and daily I battled with feelings of desolation and melancholia.

Norman Rockwell is Kinkade's idol. In Kinkade's studio (called "Ivy Gate Cottage") hangs an original Rockwell illustration. Kinkade's hero worship of the illustrator goes so far that he made a pilgrimage to Norman Rockwell's original studio in Arlington, Vermont (now a bed and breakfast). He obtained permission to paint in the master's studio, fulfilling a lifelong dream. In search of Rockwell's America, for a time Kinkade became a hobo and rode the rails from coast to coast with only his knapsack and sketchbook, recording the American way of life.

Thomas Kinkade sees himself as heir to the tradition of Walt Disney. Our world has become Disneyfied in many ways, and traditional stories and myths have found their way into Disney films. Disney trademarks have appeared on almost every object known to man—the Disney Corporation even built the entire town of Celebration, Florida, as a utopian Main Street-like community. Still, Kinkade has surpassed Disney in his infiltration of daily life. You can live your entire life using only Kinkade trademark objects, living in a Kinkade tract home in The Village, a Thomas Kinkade gated community in Vallejo, California, or in a rustic log cabin with Kinkade prints hung on the walls, reclining in your Kinkade La-Z-Boy. Your home is furnished with Kinkade grandfather clocks, night lights, lamps, calendars, cups, dishes, pillows, blankets, fabric, wallpaper, music boxes, books, Bible covers, Christmas ornaments, nativity scenes, stained glass, tote bags, clothing, puzzles, toys, canoe oars, wrist watches, key chains ("ad nauseam," as Kinkade says). Even in death, you can have Kinkade funeral announcements.

In *Thomas Kinkade: Heaven on Earth,* we have taken Kinkade's work to what I see as its logical conclusion. He paints chapels and religious art, so we have constructed a life-sized chapel, filled with Kinkade's Christian art, where sermons are preached. His original paintings and sketches are displayed in a contemporary installation, while his collectibles are placed on forest green walls like those of the Kinkade Signature Galleries. Kinkade designs houses and log cabins, and the exhibition has architectural renderings and photographs of the homes. He paints landscapes, so an area of the gallery is a woodland diorama landscaped with lush, green foliage. He has produced so many functional objects that a complete Kinkade lifestyle brand has developed, called "Living in the Light." Since he designs furniture, we have a complete Kinkade living room, dining room, and bedroom installation. Kinkade loves Christmas, so there is a Yuletide section with a huge Christmas tree decorated with heaps of Kinkade ornaments, loads of Christmas presents and prints, and a ceramic crèche. The exhibition includes a Kinkade Educational Center (with art instructional materials), the Kinkade Library & Reading Room, and the Path of Inspiration, where one can stroll down a flowery lane and read inspirational placards, cross over the Bridge of Faith, or stop at one of the photo-ops to have one's photograph taken—posed as if in a Kinkade painting.

The full scope of Kinkade collectibles seems endless, produced in quantities beyond all limits of comprehension. Like the Liberace Museum in Las Vegas, we have display cases jam-packed with Kinkade collectibles. In his imagery's multiplicity, I believe he has earned the right to carry the mantle of Warhol, far exceeding other rivals such as Keith Haring, Kenny Scharf, and Mark Kostabi. Kinkade's project is a full and total saturation.

In my exhibition "The Richard Nixon Museum," I dealt with masses of Nixon collectibles and memorabilia—everything from ping-pong paddles and puppets to roach clips and toenail clippers. In the "Nixon Museum" as well as "The World of Jeffrey Vallance" exhibition at the Santa Monica Museum of Art, I offered at the gift shops a variety of novelties imprinted with my imagery ranging from night-lights and pocket pen protectors to dishtowels and potholders. But all this pales in comparison to Kinkade's global, never-ending, expanding cornucopia of merchandise.

When he is painting, Kinkade feels closest to God. Like many artists before him, he keeps to the tradition of the artist as tool in the hands of God. He believes God speaks through beauty. Kinkade prays over each of his paintings. As a student, Kinkade fancied himself a rebel, a counterrevolutionary. When other Art Center students were doing hard-edge or photo-based work, Kinkade made "soft, romantic things with a heavy dose of imagination." Young Kinkade saw the art world as a subculture on the fringe of society that had little bearing on the average person's life. In art school, Kinkade rejected what he called the "pseudo-sophistication" of contemporary art. He wanted to appeal to normal folk, not just art critics or academics in ivory towers. His goal was to change the world, and now even his most ardent critics may have to admit that he has succeeded. Inadvertently, Kinkade has achieved what many contemporary artists have strived for—he has successfully merged art and life. He says, "I don't see my art as something distinct and different from life."

From my pedagogic experience with art students in the U.S. and abroad, I can say that the name Kinkade reverberates in the hallowed halls of academia. Among students, his work inspires lively discussion. As Kinkade says of himself, "I am really the most controversial artist in the world." Or, as his pamphlet states, "His influence knows no bounds."

In this exhibition, we have attempted to do something that hasn't been done before, and that is to inject Kinkade directly into the contemporary art world.

Perfect Day Canoe Tours
Die cast truck
Gallery Marketing Group Inc.
www.gallerymarketinggroup.com

Jeffrey Vallance is an artist, writer, curator, and a visiting assistant professor at the University of California, Los Angeles.

Wallpaper detail
Pre-pasted peelable vinyl
Thomas Kinkade Painter of Light Volume 2
Imperial Wall Décor
© Imperial
www.ihdg.com

Ralph Rugoff

The exhibition *Thomas Kinkade: Heaven on Earth* does something highly unlikely: it presents the work of Thomas Kinkade in a gallery dedicated to contemporary art. Kinkade is a living artist, and by definition he is our contemporary. But on first (and even second) glance, his work bears little apparent relationship to that diverse field of aesthetic production generally described as "contemporary art." Rather than engaging with the present moment in any discernible manner, Kinkade's paintings generally cast a nostalgic eye on a dreamily innocent and bucolic past.

Among his best-known images are depictions of winding country lanes and garden cottages, rustic cabins nestled amid majestic natural settings, and lonely lighthouses perched over storm-tossed seas. Kinkade's visual rhetoric is largely recycled from nineteenth-century landscape painting, particularly the work of the American Luminists, and in turning a blind eye to the history of modern art, his pictures offer a kind of retreat, or refuge, from the challenges and demands of contemporary culture. Conjuring idealized scenes that evince an almost otherworldly perfection, they invite viewers to share an escapist fantasy.

Yet, in a very crucial area, Kinkade's work displays a close kinship with that of Andy Warhol, the artist who, more than any of his twentieth-century peers, reinvented contemporary art practice and arguably redefined the complexion of contemporaneity itself. On the surface, of course, their work could hardly appear to be more different. In contrast to Kinkade's serenely pastoral motifs, Warhol's art focuses on the circus of the mass media. It plays on the mechanisms of fame and publicity and explores the ways in which familiar icons— whether movie stars or soup cans—are packaged for consumption. Where Kinkade's art is warm and friendly, Warhol's is cool and often spiked with undercurrents of trauma, as in his silk-screened pictures of car crashes, electric chairs, race riots, and suicides.

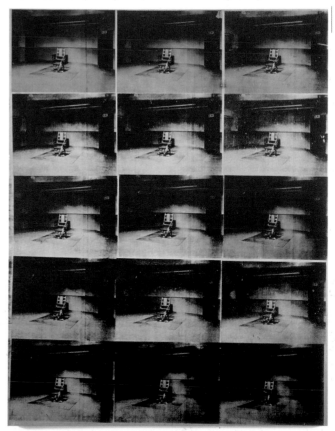

Andy Warhol, *Lavender Disaster,* 1963
Silkscreen ink and synthetic polymer paint on canvas
8'10" x 6'9 7/8
© The Andy Warhol Foundation for the Visual Arts/ARS, NY.
Menil Collection, Houston, Texas, U.S.A

Despite these considerable differences, however, the artistic practices of Warhol and Kinkade demonstrate remarkably similar attitudes toward commercial art and marketing. In very different ways, each artist has rejected that central Modernist myth that proclaims business and art to be unrelated pursuits, and the uncompromising creativity of art utterly incompatible with the profit-driven practicality of business. If Warhol

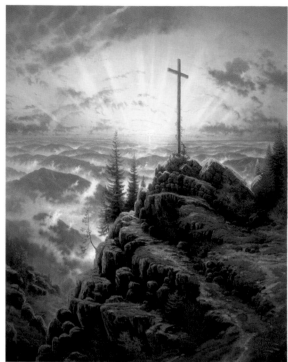

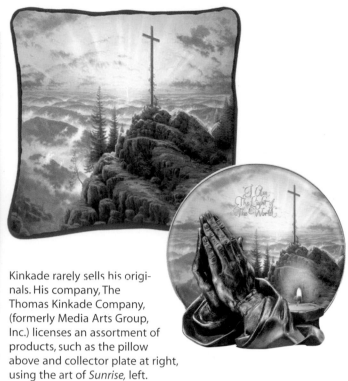

Kinkade rarely sells his originals. His company, The Thomas Kinkade Company, (formerly Media Arts Group, Inc.) licenses an assortment of products, such as the pillow above and collector plate at right, using the art of *Sunrise,* left.

stands as the radical pioneer in this revolution, Kinkade's enterprise represents the fulfillment of several of Andy's dearest dreams.

Throughout his career Warhol made statements implying that art and business were analogous, if not interchangeable. While Warhol probably took delight in shocking orthodox avant-gardists by championing the cause of commerce, this was not merely a pose. To a significant extent, Warhol's version of Pop grew out of his realization that there was little difference between what art critic Harold Rosenberg called "the tradition of the new" (i.e., the avant-garde's creed of aesthetic innovation and novelty) and the "permanent revolution" of American business culture trumpeted by publisher Henry Luce. For Warhol, in fact, business art, or the art of business, represented an advance over art: in his *The Philosophy of Andy Warhol: From A to B and Back Again,* he declared, "Good business is the best art."[1]

Warhol's attitude toward business directly reflected the changing nature of the art scene of his day. By the time he was launching his career as an artist, a professionalized art world had already become part of the larger culture industry. Marcel Duchamp, a beacon of an earlier avant-garde, bewailed this process of professionalization shortly before his death in 1968. "With commercialization has come the integration of the artist into society for the first time in 100 years," he complained. "Today the artist is integrated, and so he has to be paid, and so he has to keep producing for the market."[2] Thus, according to Duchamp, commercialization reduces the artist to the status of a mindless automaton. But where the French artist saw this as a negative and alienated condition, Warhol welcomed this new role with deadpan enthusiasm, famously declaring his desire to be like a machine.

Indeed, rather than resist the industrialization of art, Warhol organized his own "factory" and introduced commercial printing techniques into the realm of "high" culture.[3] As no artist had before him, he participated in multiple mass-media arenas. He produced feature movies for theatrical release. He founded and published *Interview* magazine, often designing its covers. He produced and designed rock-and-roll albums. He even appeared in several national advertising campaigns, including one for Vidal Sassoon hair products.

In all of these endeavors, Warhol self-consciously deployed his name and his carefully manufactured image as branding devices. In this respect, his project anticipated how, in our service-oriented economy, business practices have increasingly come to resemble those of art. Much like any artistic enterprise, branding and packaging operations seek effectively to imbue material objects with abstract values and meanings, crafting alluring "identities" for otherwise anonymous products.

Kinkade employs a similar strategy, using his paintings to form the basis of a merchandising empire. Kinkade, in fact, rarely sells his original canvases; instead, his company, Media Arts Group (now known as The Thomas Kinkade Company), markets an assortment of reproductions. These range from affordable mass-produced prints to lithographs on canvas with original highlights applied by Kinkade himself or one of his specially trained assistants. In addition, Kinkade's images are reproduced on a seemingly endless array of consumer goods, including mouse pads, calendars, cookie tins, lamps, linens, rugs, and china. The La-Z-Boy company has created a line of Thomas Kinkade, Painter of Light™ furniture vaguely "inspired" by a series of Kinkade's paintings. A planned community called "The Village at Hiddenbrooke," ostensibly based on dwellings depicted in Kinkade's pictures, opened in northern California recently, with a Kinkade gift shop the only retail outlet in the neighborhood.

By removing his original artworks from circulation, Kinkade endows each spin-off product with a distinctly Platonic dimension, as it inevitably evokes an absent archetype: namely, the unavailable original. Reinforcing this quasi-theological effect is the Christian branding that Kinkade and his company apply to his imagery. In publicity materials and in the artist's public statements, Kinkade's pictures of cozy domestic comforts and inspiring landscapes are framed as allegories of spiritual life. Kinkade's conspicuous use of radiant lighting effects, meanwhile, is implicitly equated with spiritual illumination. (Tellingly, retail galleries devoted to his work are known as Redemption Centers.) Like Warhol's elevation of a soup can or a movie actress to the status of religious icon, Kinkade's project likewise entails reframing the seemingly mundane in sublime terms—the goal, in so many words, of most marketing exercises.

Virtually all-encompassing in its approach, Kinkade's merchandising enterprise also conjures the potentially infinite landscape of branding. In this respect, it recalls not only Warhol but also the work of Jeffrey Vallance, a contemporary artist who, not coincidentally, is the curator of this exhibition. Since the early 1980s, Vallance has created several distinct bodies of work that address the wanton proliferation of branded imagery in our advertising-dominated culture. For a project based around Blinky the Friendly Hen, a frozen chicken that he adopted as a pet and subsequently transformed into a symbol of universal martyrdom, Vallance produced an extensive range of Blinky-branded souvenirs and relics. And the artist's *Jeffrey Vallance Presents the Nixon Museum* (1991-present) comprises a wildly eclectic collection of objects—wrist watches,

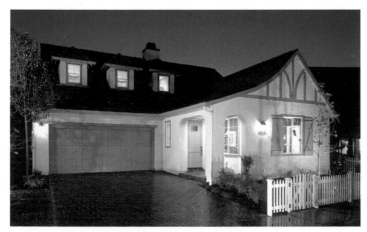

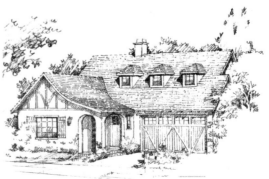

Hiddenbrooke Village, Plan 1, based on Kinkade's original drawing, right. William Hezmalhalch Architects Inc.

paperweights, ping-pong paddles, matchbooks, showerheads, and even nail clippers—all bearing Nixon's name and/or portrait.

In projects such as these, Vallance explored the theological nature of branding. Set above and beyond the promiscuous reproductions of the workaday world, the brand represents a type of social limit comparable to the sacred. Its "truth" is guaranteed only by its inaccessibility: we may possess branded objects, but we can never consume the brand itself. With absurdist humor, Vallance's art has examined the peculiar logic of this self-validating system, where the value of things is organized around a transcendent sign. At the same time, his work has insinuated that all representational languages, including art, operate along similar lines. In this schema—and in contrast to the modernist credo of aesthetic autonomy—an artwork may appear to mean radically different things depending on its context. Indeed, if the lowliest artifact can be redeemed when rebranded by, say, the Nixon logo, then clearly an object's meaning arises less from its specific qualities than from the place it occupies in a larger symbolic network.

Given these interests, Vallance's role as curator of *Thomas Kinkade: Heaven on Earth* appears to be less than innocent. By recontexualizing Kinkade's work—both his original art and merchandising spin-offs—in a contemporary art gallery, Vallance, in fact, raises questions closely related to those posed by his own artworks. Should we, then, regard this exhibition as a type of appropriation art? In ostensibly presenting the work of Kinkade, has Vallance in effect slyly created a meta-artwork of his own, a Duchampian displacement that upsets our conventional ideas of category and context? Our viewing of Kinkade's work, in any event, is changed by our knowledge of the curator's own artistic practice. In a sense, Vallance has used his status as a contemporary artist—as well as the venue of a contemporary art gallery—to repackage and rebrand Kinkade's practice, tempting us to read Kinkade through Vallance.

Vallance's ambiguous curatorial intent instills in viewers a troubling uncertainty. It leaves us unsure how to regard and how to categorize the various objects we encounter in this exhibition. At the same time, it leads us to wonder about the elasticity of our definition(s) of contemporary art. In this way, *Heaven on Earth* calls attention to the precariousness and contingency of our interpretive activity, prompting us to reconsider how pre-existing conceptual frameworks determine, and limit, much of our understanding. To what extent, in other words, is our reading of the world always a reflection of what we already believe? This exhibition provides no definite answers to the question but, instead, immerses us in a kind of game where meaning emerges from the ways that belief and unbelief work together. In inviting us to contemplate faith-based artworks, Vallance ultimately leads us to wonder whether our relationship to contemporary art has far more to do with faith than we ever imagined.

Footnotes

[1] Andy Warhol, *The Philosophy of Andy Warhol: From A to B and Back Again* (New York: Harvest Books, 1977): p. 92.

[2] Pierre Cabanne, *Dialogues with Marcel Duchamp,* trans. by Ron Padgett (New York: The Viking Press, 1971): p.65.

[3] Warhol, in other words, did not leave commercial art to become a fine artist so much as he demonstrated that the distinction between the two was largely arbitrary.

Ralph Rugoff is director of the CCAC Wattis Institute in San Francisco.

Thomas Kinkade Publications
Thomas Nelson Inc.
www.thomasnelson.com
Harvest House Books
www.harvesthousepublishers.com
Time Warner Book Group
www.timewarner.com
Photo: M.O. Quinn

Wallpaper detail
Pre-pasted peelable vinyl
Thomas Kinkade Painter of Light Volume 2
Imperial Wall Décor
© Imperial
www.ihdg.com

Thomas Kinkade

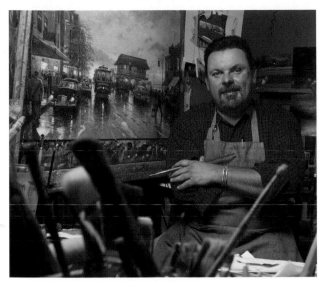

Photo courtesy of The Thomas Kinkade Museum.

Fine art is the most powerful tool for impacting a culture that I can think of. Unlike virtually all other media including film, television, books, and music, fine art is not limited by the element of time. For example, it takes about eight hours to read the average book, a movie lasts two hours or less, and a song is over in mere minutes—but a painting invades the most private of human spaces, the home, and becomes a part of that person's life for the rest of their time on the planet. And while other reproduced forms of created works often end up on a shelf or in a music cabinet, a painting or print is enshrined, front and center within the home. It surrounds the activities that take place in the home, creates the background visuals for the rituals of daily living. I have often had collectors tell me that a painting of mine is the first thing they see in the morning and the last thing they see at night. In the midst of continuous bombardment from the loud and constantly in motion imagery of our media culture, a painting is a still and silent messenger in the home—as compelling as a gentle whisper in a room full of shouting people. Further, paintings are time travelers, often handed down generation after generation long past the lifespan of the artist or the original owner.

For me the great joy of creating is the two-way dialogue it affords with an audience. The thousands of letters I receive every year prove that people are hungry for an art of meaning, an art of inspiration, an art of relevance to their daily lives. I believe that God gives each of us talents for the purpose of serving others in our own unique way. From my earliest years as a published artist, I have tried to use whatever talents I might possess to share something of meaning with people—to provide comfort, hope, and a highly romanticized celebration of natural beauty.

For many millions, my art provides an escape from the pressures of contemporary life and a gentle affirmation of such foundational values as home, family, faith, and simpler ways of living. This same function has been served by populist iconography in every American generation, be it Currier & Ives prints, Frank Capra films or Norman Rockwell *Post* covers. As to the myriads of products that have been developed from my paintings, I can only state that I have always had the attitude that art in whatever format it is accessible to people, is good. I don't look down upon products of any type, because all forms of art reproduction have meaning to some body of people. And the popular, even plebian, arts of one generation often become the valued heirlooms of future generations—or at the very least a telling reflection of the nature of commerce in that era.

My hope is that an art of human dignity, cultural service, and practical relevance will reemerge in the 21st century mainstream. This is a valid and proven function for the visual arts—as valid as experimentation and newness for its own sake. At the very least, it is clear that everyday people need an art they can enjoy,

believe in, and understand. Though this paradigm for the arts seems at odds with the mandates of modernist thinking, it need not be. The two creative streams may simply be fascinating parallel universes, as unrelated to each other as pulp fiction is to avant-garde poetry. Or it might simply be that we live in a post-modernist era and the boundary between high art and popular art has been irretrievably blurred.

Which leads us to the current *Heaven on Earth* exhibition. The assemblage of a broad range of Kinkade cultural output has never been attempted before, and I applaud the effort. The exhibition is ambitious, unconventional, and perhaps a bit paradoxical—and I find all aspects of the project exhilarating. Perhaps, in the end, I have spent these many years trying to share broadly with others my own very idiosyncratic and emotionally charged visions of an earthly paradise. Perhaps the arts allow the spirit of both artist and patron to take wings and reach for the heavens, albeit the imperfect heavens of the human imagination. Perhaps that is what art has always done and will always continue to do.

Thomas Kinkade

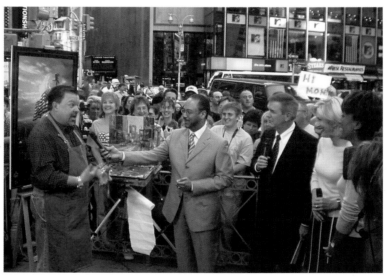

Thomas Kinkade appears with *Good Morning America* hosts on September 13, 2002, to paint a Plein Air painting live in Times Square. Photo courtesy of The Thomas Kinkade Museum.

Doug Harvey

Q: Who is the most successful artist to have graduated from Pasadena's prestigious Art Center College of Design?

A: If you guessed high-modernist-design copycat Jorge Pardo, you're only getting warm. The artist in question, while similarly blurring the lines between fine art and furniture and extending the artist's domain to include the construction of entire domiciles, regularly posts annual sales in excess of $100-million, and his work is estimated to be a part of 1 out every 20 households in America. Art Center's biggest professional fine-art success story is the only artist to have been named a "future hall of famer" by *US Art Magazine,* a two-time National Association of Limited Edition Dealers "Graphic Artist of the Year," and the nation's most collected living artist. Yet Thomas Kinkade, Painter of Light™ remains virtually unrecognized by the otherwise impressionable art world and is relegated to the same nebulous phantom zone as berated and mustachioed Super Bowl Playboy *artiste* LeRoy Neiman, once-decent illustrator turned sinister hack Peter Max, and the, by now, "quart-sized Picasso" Alexandra Nechita. As fine art, Kinkade's work has infiltrated the public sector on an unprecedented scale, gracing knickknacks and gewgaws of all manner and giving rise to more than 300 galleries devoted exclusively to sales of his work.

Incorporated in 1990, Kinkade's marketing and distribution company, Media Arts Group (now known as The Thomas Kinkade Company), was one of the most unusual business phenomena of the turning millennium. Ranked fourth on *Business Week's* May 1999 list of "Hot Growth Companies" and placed in the top ten of *Forbes Magazine's* 1998 list of the best small companies in America, Media Arts Group claims to pursue an innovative strategy of "lifestyle branding," a scheme that involves getting consumers to identify Kinkade's name with traditional family values by licensing it to a variety of essentially pseudo-Victorian home-furnishing lines. This, in turn, draws even more people into the carefully monitored Thomas Kinkade Signature Gallery franchises, where the bulk of commerce takes place. Drawing from a library of 170 Thomas Kinkade images, Media Arts Group manufactures a baffling array of products, from magnets and cookie tins to every imaginable permutation of framed or unframed photolithograph on paper or canvas. These reproductions, ranging from the $195 nine-by-twelve-inch prints on paper in the Classics Collection to the $15,000 Master Edition Canvas Lithographs—which come with "personal retouching by the artist himself," the artist's thumbprint, a Master Edition Seal, an authorized security signature, and yet a second signature in metallic ink—are the company's meat and potatoes.

For those of lesser means, there is the Thomas Kinkade Plein Air collection, the Thomas Kinkade Portfolio Edition, the Thomas Kinkade Library Print Edition, the Thomas Kinkade Inspirational Print Collection, the

THE *USA TODAY* BESTSELLER

THOMAS KINKADE

LIGHTPOSTS *for* LIVING
The Art of Choosing a Joyful Life

"INSPIRATION FOR READERS...A RADIANT READ." —*OAKLAND PRESS*

Thomas Kinkade Lightposts for Living
The Art of Choosing a Joyful Life
Time Warner Book Group
www.timewarner.com

The kitchen of Tollhouse Cottage, Hiddenbrooke Village
William Hezmalhalch Architects Inc.

Thomas Kinkade Hearth and Home Collection, and the Thomas Kinkade Book Collection. Members of the Thomas Kinkade Collector's Society "enter a world of beauty that only Thomas Kinkade can create," paying annual dues and purchasing exclusive, members-only offerings from the pages of the Society's journal *The Beacon*. In 1998 the La-Z-Boy furniture corporation unveiled a line of more than 100 Thomas Kinkade, Painter of Light™ furniture items. The following year, Warner Books Inc. and QVC combined to give a big push to Kinkade's collection of self-help aphorisms, *Lightposts for Living,* which was followed by scores of other publications, from parenting manuals to a trilogy of soap-operatic novels set in the fictional Kinkadesque town of Cape Light. Also in 1999, Media Arts announced a licensing agreement with Houston-based U.S. Home Corporation for the construction of homes, and ultimately entire planned communities, inspired by Kinkade's work. The first such community, part of the planned enclave of Hiddenbrooke north of San Francisco, opened—with an unsettling serendipitous poeticism that underscored its underlying theme of retreat from the harshness of contemporary life—in September of 2001. From inspirational desktop screensavers to *Music of Light* CDs to chapel-shaped dinner table centerpieces to something called the "Sunrise Magnetic Flap Journal," there seems to be no aspect of contemporary culture to which Kinkade's vision is inadaptable. What may appear to be merely classic marketing is nevertheless a successful instance of the fine arts competing with the mass media, and deserves close attention.

Kinkade differs from his fellow gilded ghetto dwellers of fine-art collectible land, however, in that his work makes no token concessions to Modernist and Postmodernist reorderings of visual language. Overtly, even militantly, sentimental (like the work of his idol Norman Rockwell), Kinkade's detailed work-manlike renditions of traditional, quasi-Luminist landscapes, inhabited by homely cottages and stone lighthouses, neatly bisected by babbling brooks and waterfalls, and track-lit from Heaven through a conveniently parting storm front, are quintessentially picturesque. That is, they are pictures that look like scenes that look like pictures. With the licensing of furniture, linens, chinaware, and housing designed to look like it came out of a Kinkade painting (in addition to the more typical licensing of giftware bearing reproductions of an artist's imagery), the layers of simulation become thick enough to conceal the source. The camouflaged invisibility of sentimental pictorialism in our visual culture—where the pathetic fallacy can only penetrate the art world through the orifice of ironic appropriation, while at the same time almost saturating the ground of popular visual culture (television, movies, and advertising)—is the loophole Kinkade and his corporate associates intend to stretch wide enough to free us all.

Free us from what, though? To those who remain cloistered and self-involved in today's art world, Kinkade's crusade may seem to be merely a calculated exploitation of the reactionary media image of modern artists as sneering hucksters, which derives meaning from its oppositional relationship to the drip paintings, meat spectacles, and Duchampian relocations that have fueled tabloid rants since forever. But apart from a few incidental (and disparaging) mentions, the literature on Kinkade is devoid of any reference to contemporary art. Thomas Kinkade, Painter of Light™ brochures, catalogues, and annual

reports are nevertheless laced with statements about the meaning and function of art in the contemporary world, more often than not mouthed by a member of the Board of Directors of Media Arts rather than Kinkade himself. "Art is an incredibly powerful communicator which can, and should, be as relevant to people in our culture as movies, books, music, or television." Right on!

The first time I entered a Kinkade franchise and told the proprietress that I was thinking about writing an article on the artist and his work, a wall of suspicion immediately dropped between us, and she informed me that I couldn't do that without the permission of the Company. This was the first hint of the paranoiac cultishness that gives the massive enterprise its ominous edge: Kinkade's landscapes are reminiscent of the pastoral scenes at the beginning of Terry Gilliam's 1985 film *Brazil* that are revealed as only billboards masking gray postindustrial ruins. In this sense, Kinkade's empire provides a more real, if cruder, version of the picture of popular culture that the overly Gnostic strains of contemporary cultural criticism identify as a wholly malevolent and patently false model of reality, designed to distract and coerce us into a mass denial of our individual misery.

Be that as it may, the art produced or championed by adherents to this line of argument (that is, the entire cultural niche that values the insights of Jean Baudrillard over those of Dale Carnegie) is as vigilantly, if less forthrightly, committed to the policing of the status quo as any Hallmark greeting card or network newscast. Their audience is just smaller, and dresses funny. Why should we believe that telling people "Everything's all right because I am a clever, privileged manufacturer of contemporary cultural objects" is more convincing to some friendless, lactose-intolerant middlebrow who lives and works in a cubicle than "Everything's all right because you can imagine you are walking down this pre-industrial English country lane and a nice lady is making you lactose-free cocoa in that stone cottage"?

Kinkade's strategy is not one of rehabilitation of the existing art world, but an establishment of an entirely new parallel art world, one that defies high and lowbrow distinctions and teleological models of art as a formalist polemic awaiting completion, subverts the established hierarchy of the gallery and museum system, and cuts a swath through the tangled elitism of the academic paradigm. These are, of course, the declared ideals of all good Postmodernists. This phagocytic configuration is constructed through a relentless forging of a new distribution network by which the public may encounter art and expect to have a positive experience, as well as by the artist's radical usurpation of protocol. Wholly on a par with Komar and Melamid's Most Wanted art project (though not requiring quotation into the high-art establishment for validity), Kinkade accomplishes his feat by going to the public to find out what constitutes a worthwhile art experience, rather than by dictating one to them. Kinkade invites us to join him in "letting our light shine to illuminate a world of beauty and grace."

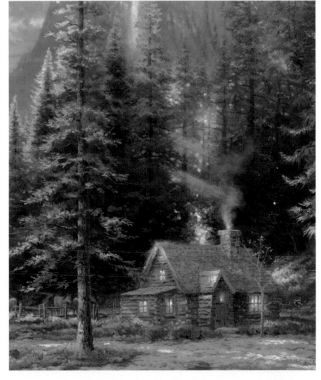

Detail from "Mountain Majesty"
Image courtesy of The Thomas Kinkade Company.

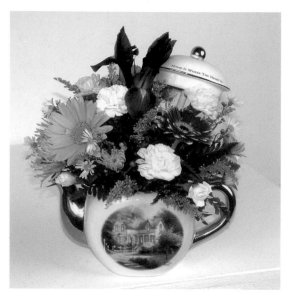

Home Is Where the Heart Is
Ceramic teapot and floral arrangement
Teleflora, www.teleflora.com

The Messianic tint to Kinkade's artistic persona is no accident. The artist's apparent separateness from the ominously anonymous Media Arts Group; the cultlike atmosphere of his galleries with their prescribed litanies ("Is this your first experience of the art of Thomas Kinkade?"); the ritualized dimming of gallery lights; the artist's power to transubstantiate a relatively inexpensive lithograph into a high-priced "semi-original" through the merest application of paint daubs; the implicit equation of accomplished illusionistic lighting effects with mastery over spiritual illumination; the attribution to the artist and his work of the shamanistic power to transport nonvisionaries to parallel realities; and countless other carefully orchestrated aspects of Kinkade's packaging all paint the artist as avatar, the embodiment of godhead. This way of understanding and bestowing meaning and authority on artistic activity is as old as culture. It is only in the last 150 years that artists have rejected it, railed against it, and refused to take advantage of it. Kinkade has tapped into a vast reservoir of art-related archetypal energy which crispy academics have failed (alongside racism and narrative) to wish out of existence.

The use of imagery as a key for unlocking inner experiences, swept under the carpet in an attempt to rid it of the condescending overtones of therapy and forfeited in the fifteen-seconds-per-picture mode of museum trolling, is one of the most psychologically and biologically profound effects of visual art. From the cave paintings at Lascaux to the ancient traditions of Tibetan and Navajo sand painting and from Grünewald's Isenheim Altarpiece to the paintings of Mark Rothko, the use of pictures as visual aids in initiating and guiding inner "journeys" uniformly depends upon dim lighting, privacy, prolonged access to the artifact, an understanding of the translatability of the design into illusionistic depth, and freedom from self-consciousness in order to effectively trigger a deep animal response. This kind of visual material is no longer a consensually validated way of understanding art; yet it has never really gone away. Given the strength of the psychological hook it wields and the utter isolation most regular Joe's feel toward contemporary art, it's small wonder that no matter how disdainfully we sophisticates ignore the *Old Mill* and the *Little Cottage Down the Lane,* they just won't go away.

Through a concerted and intricate advertising strategy, Kinkade and Media Arts Group have reinscribed their high-numbered editions of sentimental pictorial lithography with the aura of the artist. Positioning art as an understandable, explorable, available, and positive experience for a large public, Kinkade is tapping into a deep yearning of the American public to participate in the art world. What he understands (and many of his fellow Art Center alumni do not) is that people *consciously* prefer to be seduced into agreement rather than bullied into making up their own minds. People want to be rewarded for paying attention. To refuse to participate in such hardwired and unavoidable acts of commerce on the basis of moral superiority is, if not puritanical, hypocritical, and fascist, then just plain stupid. Although the recent economic downturn and an unprecedented level of saturation have resulted in a dilution of this aura (and some publicly-voiced financial distress from franchise gallerists), Kinkade has remained steadfast to his vision, working extensively with charities, actively promoting the pivotal role of art education in the public schools (including the licensing and development of the Kolorful Kids™ curriculum and instructional video set), and, finally—on January 29, 2004 - buying back all public stock in Media Arts Group at $4.00 a share: a bottom-line statement of confidence in the continued demand for his message.

Intentionally or not, Thomas Kinkade Galleries and Media Arts Group have also created a most telling art-world intervention, on a par with Jeffrey Vallance's clandestine 1977 electric switchplate solo exhibition at Los Angeles County Museum of Art and Hans Haacke's 1971 exposé of the real-estate holdings of Guggenheim Museum trustees. "From the outset," writes Chairman Ken Raasch, "Media Arts Group has changed the paradigm of art." We're often told that the ability to mobilize opposition is a measure of dialectical currency. So, consider the following: Answering yes to the question "If art can be anything, can't copies of furniture or graphic design or advertising be art?" will likely get a rise only out of the furniture designer or graphic artist or advertiser from whose work you are profiting. But then consider this: Answer yes to the question "If art can be anything, can't mass-marketed prints of nineteenth-century-style romantic landscapes be art?" and you will get virtually every expert opinion on the matter lined up against you. To participate in any of the conceptual sleight-of-hand acts in current circulation as an art experience, you have to "get it." To be allowed to sit in a Kinkade La-Z-Boy, you just have to get it. And Nature, Family, Serenity, and Spiritual Light are included with even the most modestly priced Thomas Kinkade lifestyle accouterment.

At the same time, Kinkade's work raises more questions about what constitutes art in contemporary culture than almost everything from within the art world it aims to supersede. While skittish dilettantes tiresomely mine yet another implicit but unexplored incremental variation on early-seventies avant-gardism in search of a *frisson* of wrongness to momentarily confuse their consumers into thinking they're actually questioning what constitutes art and its role in our culture, Kinkade and associates blast through such twee niggling with what amounts to a manifesto for the new millennium. A fractally detailed hybrid of the high-pitched busyness of commercial culture and the low hum of contemplative interiority, Kinkade's great work reads like a hypertextual marriage of the two most seemingly opposite cultural strains of our time. For an art world that shrugs as it continues to find titillating ways to throw the baby out with the bathwater, it ought to serve as a wake-up call.

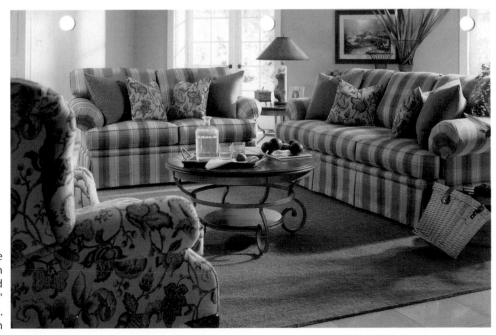

Thomas Kinkade Home Furnishing Collection La Z Boy furniture ad for Series 895, "Chalet" La Z Boy Inc. www.lazyboy.com

A version of this essay appeared in "Doug Harvey's Skipping Formalities" column in the September 1999 issue of *Art issues.* Doug Harvey is art aritic for the L.A. Weekly and an artist.

Wallpaper detail
Pre-pasted peelable vinyl
Thomas Kinkade Painter of Light Volume 2
Imperial Wall Décor
© Imperial
www.ihdg.com

Mike McGee

Some Historical Perspective…

"The critics may not endorse me, but I own the hearts of the people," claimed Thomas Kinkade in 1999.[1] In 2000, Kinkade outlined his three-phase plan to "restore dignity to the arts"[2]: phase one, "promote himself as the most successful artist in the culture;" phase two, build "a highly successful corporation around himself."[3] And having accomplished phases one and two and formed the Thomas Kinkade Foundation, he endeavors to proceed with phase three, to create a viable alternative to a contemporary art world that he views as indecent, "inbred," and not in touch with America. As he puts it, "I don't want to clean up the outhouse, to close the Whitney. I want to build a temple next door."

Kinkade is correct to cite the Whitney Museum of American Art as an emblem of the avant-garde in this country today and as the antithesis of what he is attempting to achieve with his art, yet there is a certain irony in his assertion. When Gertrude Vanderbilt Whitney and her circle founded the museum in 1931, it was launched as the de facto headquarters for the strongest art-of-the-people movement in American history, namely, American Scene Painting, or Regionalism. In what is now a largely forgotten and seldom discussed chapter of the museum's history, the Whitney's first mission was to serve as an antidote to the brand of radical Modernism endorsed at Alfred Stiegletz's compact 291 Gallery and by Alfred H. Barr, Jr.,

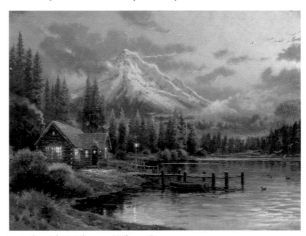

across town at New York's Museum of Modern Art. Barr was a seminal champion of the European Modernism that was often met with disdain in a generally xenophobic, isolationist, and proud pre-World War II America. The Whitney even went so far as to host a series of debates as to which was the more important art form, Modernism or American Scene Painting. Billed as "Nationalism in Art—Is It an Advantage," the 1932 debates pitted panels of authorities from both camps against one another.

In the end, *Art Digest,* the most widely read national art publication of the day, reported that the proponents of American Regionalism prevailed and that European-

Lakeside Hideway, Oil on Canvas
Image courtesy of The Thomas Kinkade Company.

based Modernism was just a flash in the pan that would not be remembered in a few decades. History, of course, has proven just the opposite to be—at least to this point in time.

But Regionalism did have its day. In 1934, publishing magnate and cultural tastemaker Henry Luce's magazine, *Time,* featured Thomas Hart Benton's self-portrait on the cover, accompanying the feature article "The U.S. Scene in Art." Edward Alden Jewell, art critic for the *New York Times,* announced in his 1939 address to Yale's art school graduating class:

> *Despite the uncertainty, unsettled conditions, the state of affairs all about us, here in America opportunities such as never before could be found welcome the artist on every hand. The artist is being lifted out of the relatively small luxury class. He is being assigned, if I may put it so, to the people.*[4]

Regionalism was the official style of FDR's New Deal, which sponsored murals in towns all across America. Regionalist artists even engaged in the first mass marketing of art; a company called Associated American Artists (AAA) sold artist etchings and lithographs, first in department stores, then, more successfully, through the mail for $5 a print ($7 framed). By the end of the 1930s, founder Reeves Lewenthal would grow AAA into "the largest commercial art gallery in the world," but sales were modest in comparison to Kinkade's $100 million plus annual revenues.

Although Regionalism still maintains a degree of popularity today, its zenith was in the thirties, and by the end of the decade even the most ardently supportive critics began to join the mounting bandwagon of detractors. In 1946, H.W. Janson, who would publish in 1962 the textbook that indoctrinated a generation of college students in art history, blasted the Regionalists in a *Magazine of Art* essay.[5] Although many other critics attacked the Regionalists, Janson may have been the most vicious; he rebuked their popularity as a form of mass hysteria and asserted that a summary write-off of the Regionalists was essential to the vitality of American culture. He saw them as anti-modern and a stumbling block to America's assuming a leading role in international art.

Regionalism's demise can be attributed to many factors. Undoubtedly, the movement did not benefit from the peccadilloes of its champions. Thomas Hart Benton, one of the most talented artists of the group, was also probably the most vocal and frequently published. He often engaged art world stalwarts in the press, and his inebriated remarks at a 1942 press conference, about how the "museum boys" were wrecking the art world, contributed to his dismissal from the Kansas City Art Institute. Even as late as 1969, in one of his two autobiographies, he complained about "fairies'" sensibilities: "A very real danger to the cultural institutions of the country lies in the homosexuals' control of policy."

Regionalism's literary mouthpiece and staunchest advocate, Thomas Craven, also had a few rough edges. In his breezy, misogynistic, xenophobic, vitriolic 1934 book, *Modern Art,* he discounted and discredited Van Gogh, Gauguin, Modigliani, Matisse, and Picasso; elevated Benton, to whom he devoted an entire chapter, and the other Regionalists; complained about what he called "the snob spirit"; and railed against the lazy French-bohemian, café lifestyle as opposed to what he saw as the more enlightened American no-nonsense work ethic—all this prefaced by the first chapter wherein he belittled the "young French girl" with whom he shacked-up when he visited Paris as a youth.

Hidden Cottage Series
Woven pillows and throw blanket
Mohawk Homes Goodwin Weaver Collection
www.goodwinweavers.com

Any hopes the Regionalists may have had of regaining their position in history in the twentieth century were effectively dashed in the 1940s when Clement Greenberg, preeminent critic for early post-World War II art, touted kitsch—essentially anything popular amongst the masses—as the gravest converse to high art. Although the authority of Greenberg's attack on kitsch has waned,

particularly in the aftermath of the Warholian celebration of popular culture, the wake of his opinion is still sufficient to tint any serious consideration of Kinkade today.

In 1954, the Whitney sold *The Arts of Life in America,* the mural that had greeted visitors to the museum since it had been commissioned of Thomas Hart Benton in 1932, to the New Britain Museum in Connecticut.

While Kinkade's tightly rendered scenes that are expressly Anglo/American may look similar to the Regionalists' subject matter and style, and while he may agree with many of their views on Modernism, Kinkade is influenced more by Impressionism. Impressionism had its roots in 1880s Paris, but its influences arrived *en masse* decades later in America. Many of the Regionalists were reacting against Modernism, but many were also responding against a generation of American artists who had embraced Impressionism. The Regionalists saw their American predecessors as overly sentimental, particularly in their penchant for

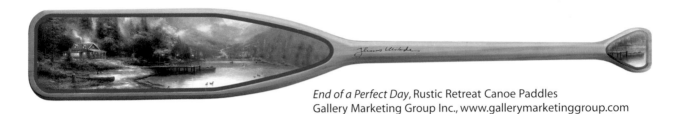

End of a Perfect Day, Rustic Retreat Canoe Paddles
Gallery Marketing Group Inc., www.gallerymarketinggroup.com

idyllic landscapes and romanticized portraiture, and they wanted to create art that was not sentimental. Americans John Sloan, Robert Henri, and the Ashcan school artists, who had endorsed the depiction of ordinary, often masculine, aspects of American life, influenced many of the Regionalists.

Kinkade, however, sees himself as the chief proponent of sentimentality in art today. His agenda to endorse a "traditional" style of art that has broad appeal and to evoke sentiment with his art separates him from the contemporary art world. "High culture is paranoid about sentiment," Kinkade told the *New York Times* reporter in 1999, "but human beings are intensely sentimental. And if art does not speak a language that's accessible to people, it relegates itself to obscurity."[6] He sees his art and the mission of his Foundation as "a form of sabotage" to the art world. As he put it, "I view it as a Trojan horse that we're sending into the enemy camp."

His is not the first broadly acknowledged attack on Modernism and, by extension, contemporary art. Thomas Wolfe's thin little book *The Painted Word,* first published in 1975, thoroughly lampooned Modern art, from the dress code at opening receptions to the artists' dependency on the written word to "explain" visual objects. Morley Safer, in his *60 Minutes* exposés in the 1990s and in subsequent debates on PBS's *Charlie Rose* show and at the Museum of Modern Art, accused the art world of being filled with "junk" and argued that the sale of such proved that there is indeed "a sucker born every minute." Also in the 1990s, Senator Jesse Helms and other conservative political and religious leaders mounted a campaign against contemporary art on moral grounds; although the campaign lingers still, it was punctuated by the tribulations of performance artists Karen Finley, Tim Miller, John Fleck, and Holly Hughes, now infamously remembered as the NEA Four, and the acquittal of Cincinnati Contemporary Art Center director Dennis Barrie on obscenity charges for displaying *The Perfect Moment,* an exhibition of Robert Mapplethorpe's photo-graphs. Just as the decade turned into the new millennium, New York Mayor Rudy Giuliani expostulated in reaction to the controversial-by-design Young British Artists' *Sensation* exhibition at the Brooklyn Museum: most of the objections focused on the elephant dung in Chris Ofili's mixed-media painting, *The Holy Virgin Mary* (1996).

Lights of Freedom, Woven throw blanket
Mohawk Homes Goodwin Weaver Collection
www.goodwinweavers.com

More recently, Paul Johnson, British amateur scholar turned prolific writer of popular historical essays and tomes, released his newest effort, *Art: A New History* (Harper Collins, 2003). In this ambitious overview of Western art history, Johnson dismissively labels most contemporary art since Picasso "fashion art": art based entirely on novelty and void of any artistic skill. Johnson, also an amateur painter, doesn't weigh in on Kinkade, but he does promote several obscure twentieth-century artists who share stylistic similarities with Kinkade.

In his provocative book *The Ethics of Memory* (Harvard University Press, 2002), Avishai Margalit thoughtfully considers the mechanisms of communal memory and how it affects societal decisions and attitudes. I believe that most artists and curators today are aware of the criticism of contemporary art in recent decades by Kinkade and others, but they may not know the details of the Regionalist epoch—Freud, however, insisted that repressed memories played the most significant role in shaping people and society. In any event, any art world consideration of Kinkade is not just about Kinkade; it stirs up a hornet's nest of troubled historical chapters and unwelcome challenges to core beliefs that overshadow his art.

Looking just at the paintings themselves, it is obvious that they are technically competent. Kinkade's genius, however, is in his capacity to identify and fulfill the needs and desires of his target audience—he cites his mother as a key influence and archetypal audience—and to couple this with savvy marketing. He is probably the only artist in history who can claim to have his works in 10 million homes across America. While Kinkade rejects Andy Warhol's artistic merit, if Andy were alive today I think he would celebrate Kinkade's success with the masses. Warhol, after all, participated in an exhibition with LeRoy Neiman at the Los Angeles Institute for Contemporary Art in 1981.

When Kinkade claims "museums are dying" in America, the reference is presumably spiritual, as by many measures museums and contemporary art are flourishing: museum attendance is higher than ever; auction prices, particularly for contemporary art, continue to set record highs; and one need only to look at the dozens of contemporary art biennials and art fairs springing up all over the world to realize that contemporary art is more popular than ever—all this happening at the same moment in history when Kinkade is the most popular artist in America, attendance at churches is on the rise, and there is a Republican in the White House.

George W. Bush is on the cover of a recent issue of *Time* magazine (December 1, 2003), a black eye on one side of his face and a red-lipstick kiss on the other side. The headline reads "Love Him! Hate Him! Why

George Bush arouses such passion, and what it means for the country." Sidebars to the feature article delineate how America is so clearly, and nearly evenly, divided about George Bush; the article points to a growing ideological polarization in America between the right and the left. Obviously, Kinkade is decidedly to the right in the political spectrum, and the art world is equally decidedly to the left: the gap between Kinkade and quintessential conceptual artist Hans Haacke is enormous, with the vast majority of the art world listing toward Haacke.

If Kinkade's art is principally about ideas, and I think it is, it could be suggested that he is a conceptual artist. All he would have to do to solidify this position would be to make an announcement that the beliefs he has expounded are just Duchampian posturing to achieve his successes. But this will never happen. Kinkade earnestly believes in his faith in God and his personal agenda as an artist. Although I don't buy into Kinkade's utopian vision, I do fantasize about a world where ideological issues could be battled in art institutions rather than in the streets.

But it is unlikely that Kinkade will get his Trojan horse into the Whitney anytime soon, and his scheme to put an alternative venue next to the Whitney is perhaps a bit too ambitious, even for Kinkade. For now, however, we have the Jeffery Vallance-orchestrated *Thomas Kinkade: Heaven on Earth* exhibition at the Cal State Fullerton Grand Central Art Center, possibly a slight opening in a door to the art world through which the Painter of Light™ can shine.

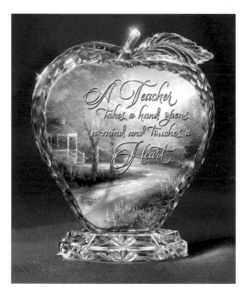

Touching the Future,
A Teacher Takes a Hand, Opens a Mind and
Touches a Heart
Crystal apple
Gallery Marketing Group, Inc.
www.gallerymarketinggroup.com

Footnotes

1 Thomas Kinkade, in Tessa DeCarlo, "Landscapes by the Carload: Art or Kitsch?" *New York Times,* Art/Architecture, Sunday, 7 November 1999, Section 2, late edition, final, p. 51.

2 Thomas Kinkade, in Randall Balmer, "The Kinkade Crusade," *Christianity Today* (December 4, 2000): http://www.christianitytoday.com/ct/2000/014/6.48.html.

3 Balmer, "The Kinkade Crusade."

4 Peyton Boswell, Jr., *Modern American Painting.* (New York: Dodd, Mead & Company, 1940): 64

5 H.W. Janson, "Benton and Wood, Champions of Regionalism," *Magazine of Art* 39, no.5 (May 1946): 184–86, 198–200.

6 Kinkade, in DeCarlo, "Landscapes by the Carload: Art or Kitsch?"

Mike McGee is director of California State University Fullerton Main Art Gallery.

THOMAS KINKADE SYMBOLISM

Bird/Eagle = Peace and freedom.

The "Light" in a Painting = "Represents God's presence and influence." It also "illuminates and guides."

Smoke of a chimney = Warmth of the home.

Light in the house = Family values.

Any type of movement = Constant change in life.

Lamp post/ Light post = Lightpost Publishing, and reminds us to share the light or to light the way. Also, welcomes friends and loved ones.

Boat = Adventure.

Pathways, Trails and Tracks = Path of life. Also the paths are lit so God can show us the way.

Stairways = Struggle through life.

Bridges = Crossing over from dark to light

Gates = Many passages we face in our lives every day and the many discoveries we have yet to make. It also means that heaven is open to all that are faithful. They are open and welcoming us in to a house or even heaven.

Windmills = Biblical symbol for the untamed human spirit.

Dogwoods = There is a story that has been passed down from generation to generation regarding the dogwood. Supposedly during Jesus' time, God cursed it into a weak and crooked tree so that no man could ever be crucified on it. When the tree blossoms, there are five petals on the flower symbolizing the five piercings. The center of the flower is red, representing the blood of Jesus.

Clouds = Represent the lives that have passed.

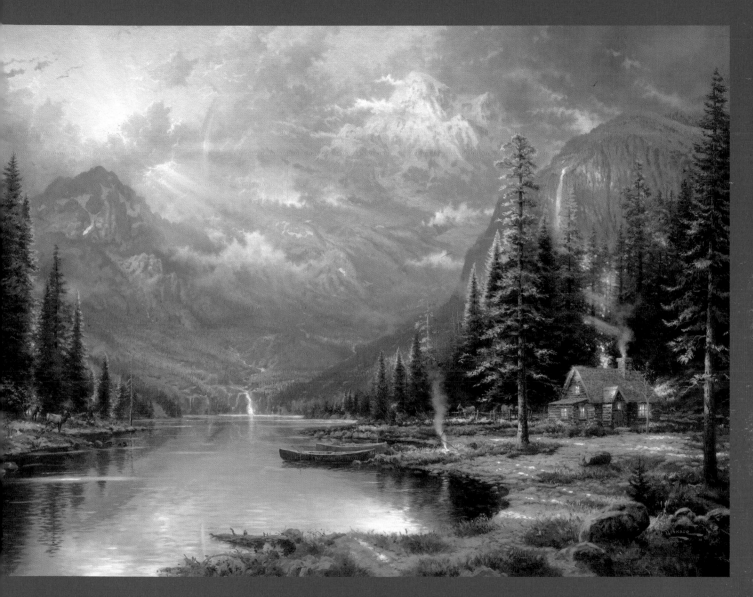

Mountain Majesty, 1998
Beginning of a Perfect Day Series
Oil on canvas, 30 X 40
Collection of Thomas Kinkade
Courtesy of the Thomas Kinkade Museum
and The Thomas Kinkade Company
Published: July 1998

This piece is majestic indeed! Thom's philosophy of "simpler times" is truly shown in this painting. A quiet cabin in the woods after a rainfall; a rainbow peeks into the sky. A tribute to his wife can be seen on the canoes. The numbers 5-2-82 are Thom and Nanette's anniversary date.

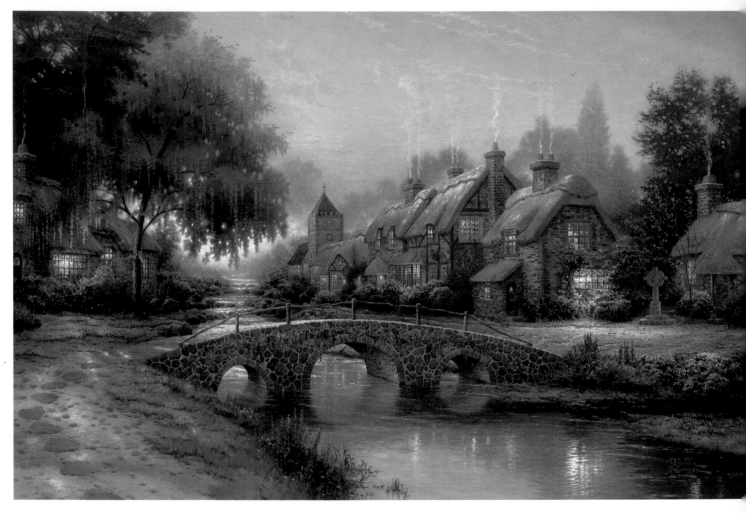

Cobblestone Bridge, 2000
Cobblestone Lane Series
Oil on canvas, 24 x 36
Collection of Thomas Kinkade
Courtesy of the Thomas Kinkade Museum
and The Thomas Kinkade Company
Published: October 2000

Based on a vacation to the Hampshire region of southwest
England, Thom decided to capture this scene as a memento
of the English countryside.

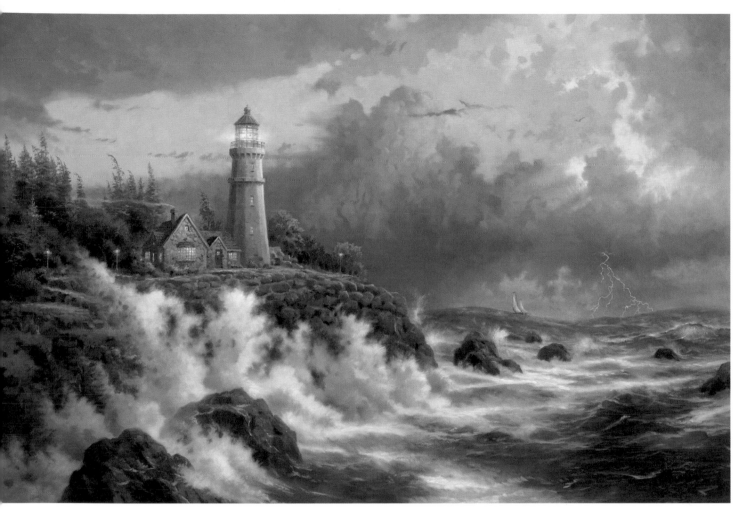

Conquering the Storms, 1999
Seaside Memories Series
Oil on canvas, 26 3/8 x 40
Collection of Thomas Kinkade
Courtesy of the Thomas Kinkade Museum
and The Thomas Kinkade Company
Published: July 1999

This painting shows two special elements, one being man-
made and the other formed by nature. Lighthouses have a
special meaning to Thom. They are spiritual beacons, which
illuminate and guide others. The lightening casting down
from above may frighten some, but Thom sees it as a
reminder of God's power.

Winter Glow, 1988
Archive Collection
Oil on canvas , 30 x 48
Collection of Rick & Terri Polm
Courtesy of the Thomas Kinkade Museum
and The Thomas Kinkade Company
Published: November 1999
Title: *Winter Glen*

In Thomas Kinkade's own words: "One of the most thoroughgoing of my Impressionist experiments displays the snow-laden boughs that are defined by patterns of light and shade; their shadows dance on the brilliantly lit path."

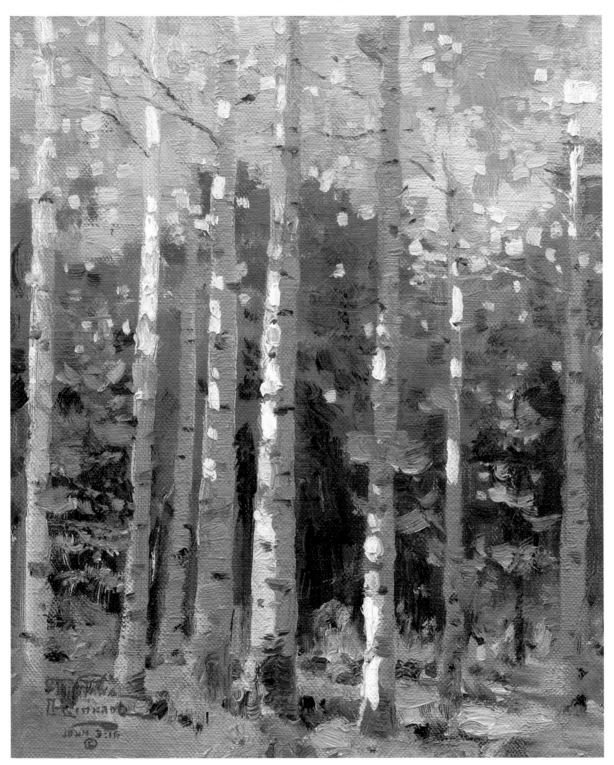

Aspen Grove, c.1999
Oil on canvas, 10 x 8
Collection of Thomas Kinkade
Courtesy of the Thomas Kinkade Museum
and The Thomas Kinkade Company

Pathway to Paradise, 2002
Visions of Paradise Series
Oil on canvas, 29 5/8 x 38 5/8
Collection of Thomas Kinkade
Courtesy of the Thomas Kinkade Museum
and The Thomas Kinkade Company
Published: July 2002

In the artist's own words—"When humankind was young,
we lived in a garden paradise. I like to think of myself as a
fellow discover on the Pathway of Paradise—one of the
fortunate few who have been granted a vision of peaceful
perfection."

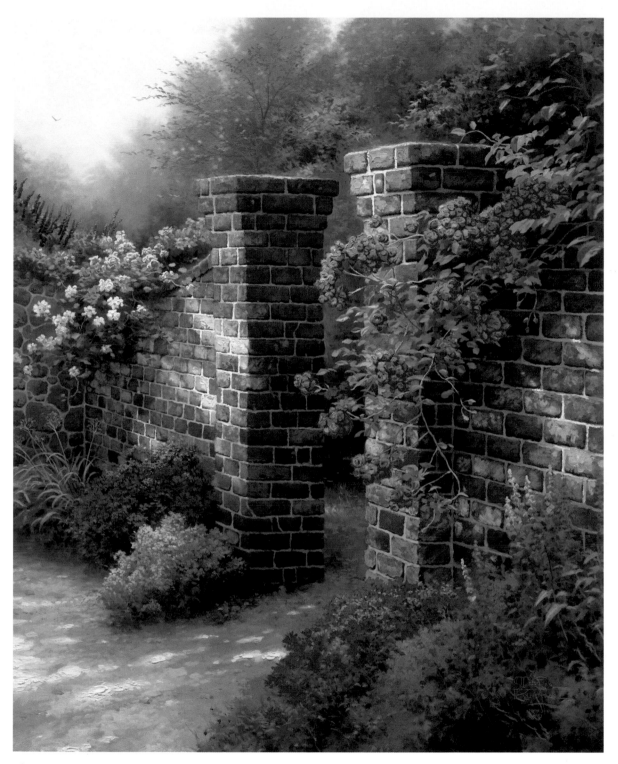

The Rose Garden, 2000
The Rose Collection Series
Oil on canvas, 25 3/16 x 20 3/16
Collection of Thomas Kinkade
Courtesy of the Thomas Kinkade Museum
and The Thomas Kinkade Company
Published: July 2000

Thom said, "Roses are the flowers of love" so he dedicated
this piece to his wife Nanette (who loves roses) and their
four daughters. This is the first painting in his Rose triptych
series. Thom used live and cut roses from his own garden
and from gardens in his town to paint this image.

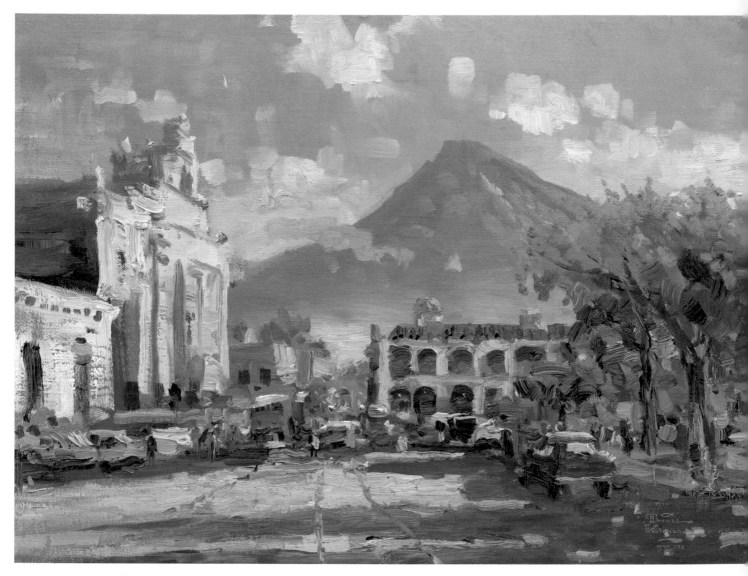

Antigua, Guatemala, 2000-01
Oil on canvas, 12 x 16
Collection of Thomas Kinkade
Courtesy of the Thomas Kinkade Museum
and The Thomas Kinkade Company
Published: 2000-01
Title, *Mountain Village, Guatemala (City)*

One special thing that touches Thom's heart is a child in
need. Last year, he visited Guatemala for an international
children's charity called World Vision. Thom created a set of
two Plein air paintings while touring Guatemala. Proceeds
from those two paintings went to World Vision charities.

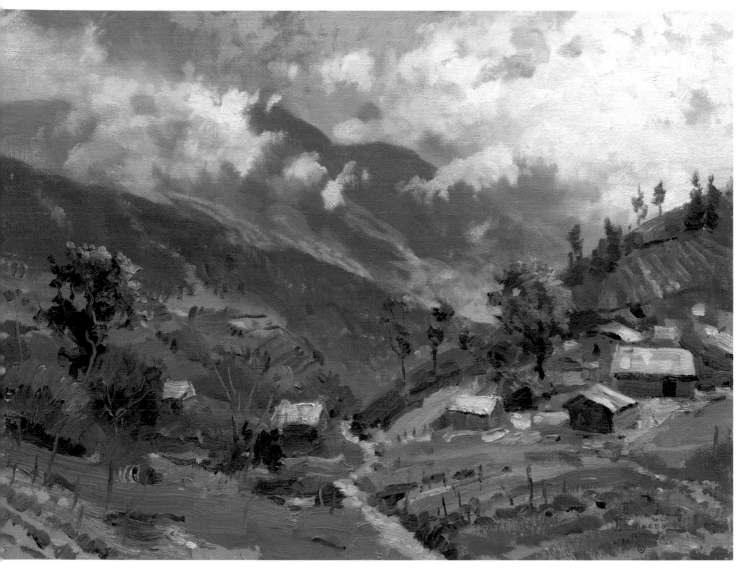

Mountain Village, Guatemala, c. 2000-01
Oil on canvas, 12 x 16
Collection of Thomas Kinkade
Courtesy of the Thomas Kinkade Museum
and The Thomas Kinkade Company
Published: 2000/2001
Title, *Mountain Village, Guatemala (Country)*

This is the second of Thom's two Guatemala paintings
for the benefit of World Vision.

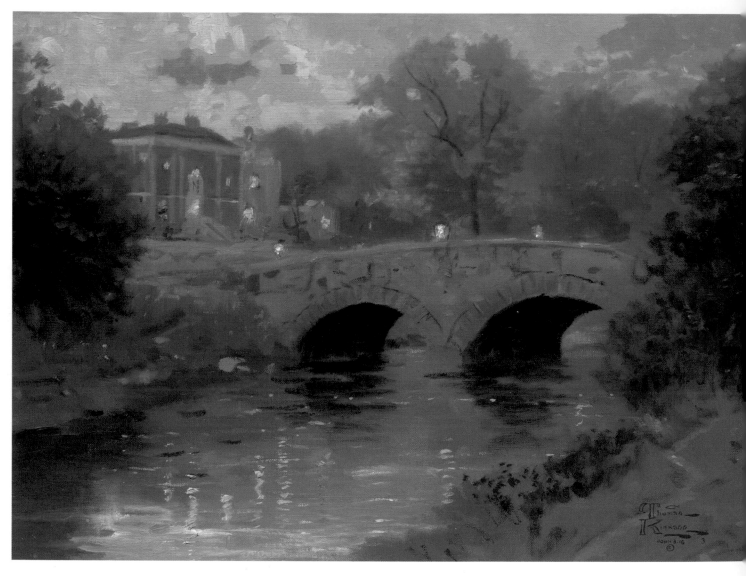

Waverly, 2000
Oil on canvas, 16 x 20
Collection of Thomas Kinkade
Courtesy of the Thomas Kinkade Museum
and The Thomas Kinkade Company
Published: 2000 in paper only for QVC in the UK

Waverly Abbey was the first Cistercian abbey in Great Britain
when it was founded in 1128 by William Giffard, Bishop of
Winchester. Very little of the abbey remains today due to
the fact that King Henry VII dissolved all monasteries in 1536.
Thom painted this site while visiting the Surrey area of England.

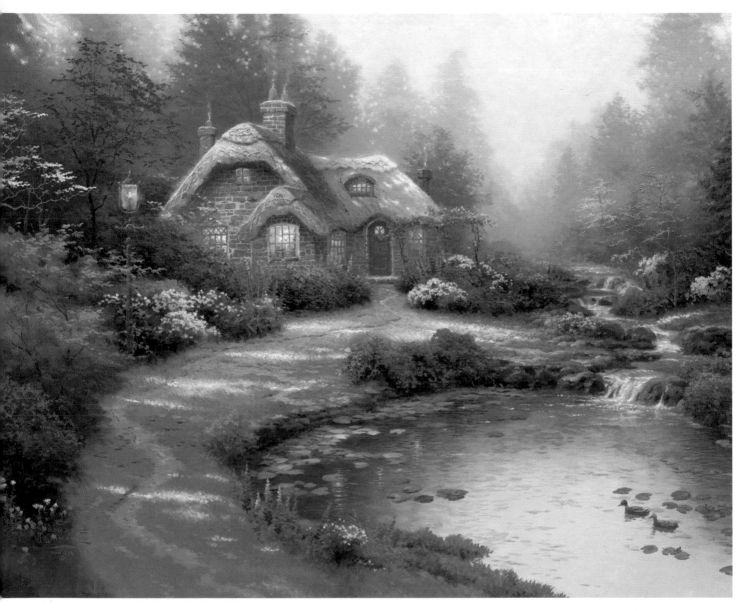

Everett's Cottage, 1998
Oil on canvas, 16 x 20
Collection of Thomas Kinkade
Courtesy of the Thomas Kinkade Museum
and The Thomas Kinkade Company
Published: July 1998

Named after his youngest daughter, Everett's Cottage is a
classic example of Thom's theme of English cottages. One
interesting fact: Thom has painted an original to celebrate
each of his children's births (the other three include *Evening
at Merritt's Cottage, Chandler's Cottage,* and *Windsor Manor*).
If you look real close through the cottage window, you can
see a picture of baby Everett. Another tribute to Everett is
the tiny letter "E" inside the heart on the front door.

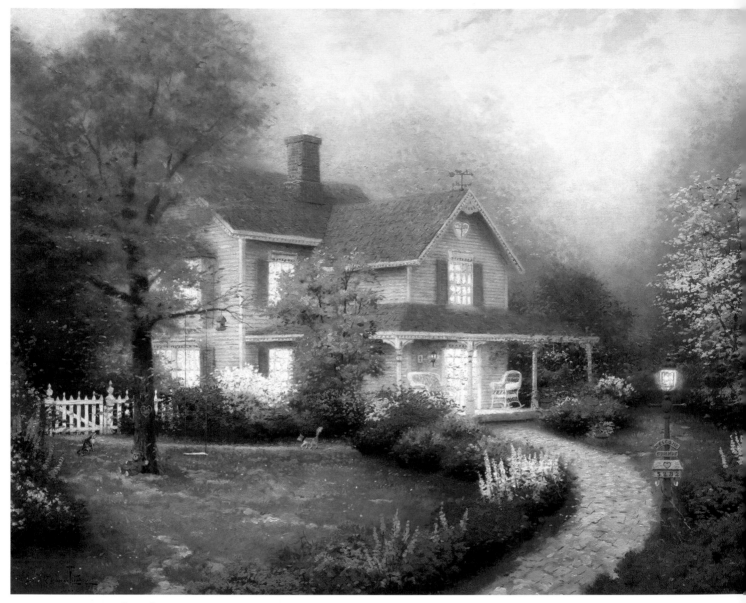

Home Is Where The Heart Is, 1992
Home Is Where The Heart Is Series
Oil on canvas, 20 x 24
Collection of Rick & Terri Polm
Courtesy of the Thomas Kinkade Museum
and The Thomas Kinkade Company
Published: July 1992

This is one of many paintings that show Thom's love for his family with its many tributes. Note the "5282" on the lamp-post and the mailbox—this is Thom and Nanette's wedding date. The swing is for his eldest daughter Merritt, and the teddy bear is for his then-youngest daughter Chandler. Cats were painted on the lawn for his children because of their love for animals. Wicker rocking chairs were painted for his wife since she loves them. You can also see a carved heart with the initials TK and NK on the tree. A sign on the lamp-post welcomes friends into their home. This home is based upon a real house in Placerville, California.

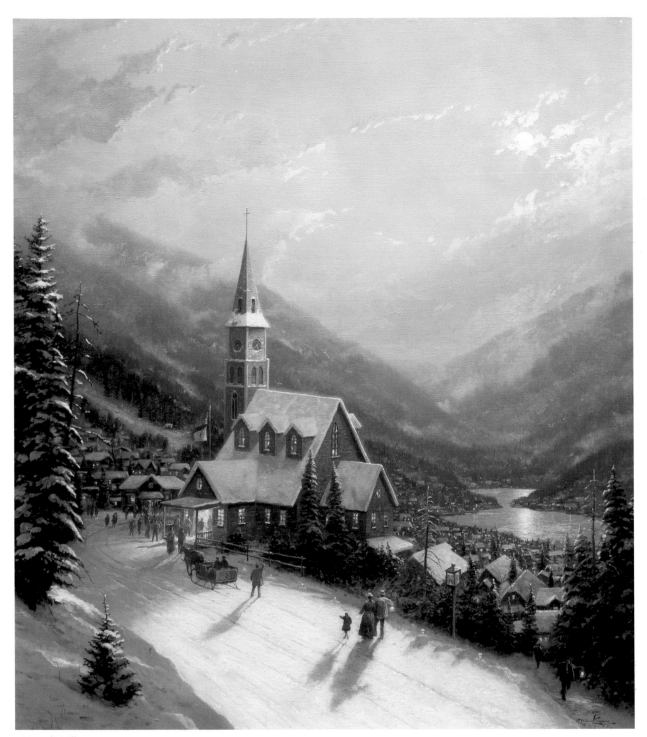

Moonlit Village, 1989
An Evening Service at the Church on the Hill, 1909
Oil on canvas, 36 x 30
Collection of Rick & Terri Polm
Courtesy of the Thomas Kinkade Museum
and The Thomas Kinkade Company
Published: 1989

Thom said that "churches are often built on a hillside or
knoll as means of emphasizing their presence in a town...so
their light can be seen afar." Inspired by small towns in
Connecticut, North Carolina, Missouri, and northern California,
Thom painted this hilltop church during a snowy night because
he "loves the effect of moonlight on the snow" and "to illuminate
the church from within." The lighted candles inside the sand-
filled paper bags were inspired by Thom's neighbor who
places these beauties along his home at Christmas time.

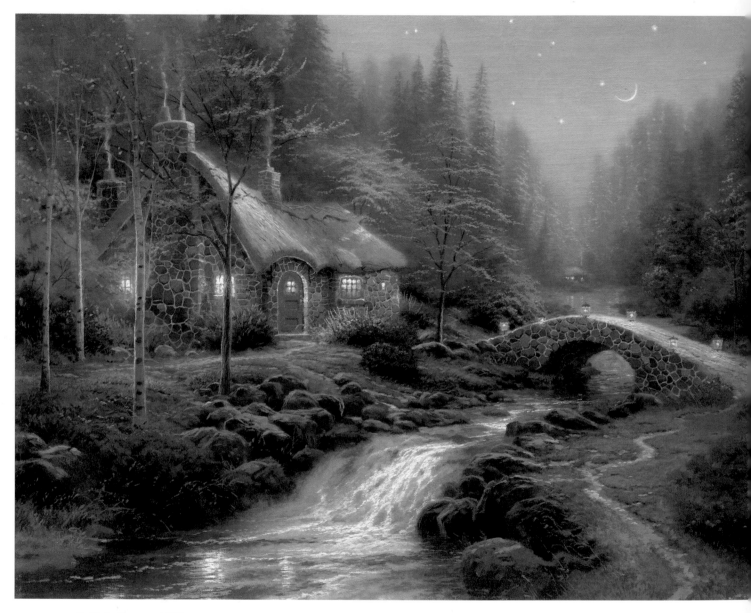

Twilight Cottage, 1997
Cottages of Light Series
Oil on canvas, 16 x 20
Collection of Thomas Kinkade
Courtesy of the Thomas Kinkade Museum
and The Thomas Kinkade Company
Published: June 1997

Thom loves to paint cozy and romantic dwellings. While
some of his paintings are based on real locations and sites,
Thom used his imagination to create this romantic getaway.
This charming cottage is under a blanket of stars while the
crescent moon peeks through the night sky.

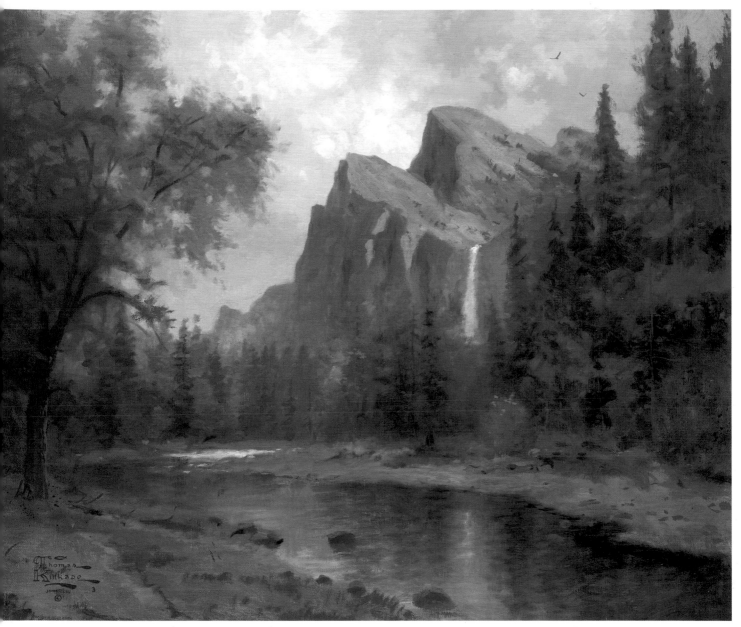

Yosemite Study, 2000
Oil on canvas, 20 x 24
Collection of Thomas Kinkade
Courtesy of the Thomas Kinkade Museum
and The Thomas Kinkade Company
Published: May 2000

Thom painted this Plein air color study while vacationing
with his family in Yosemite. He then used this study to
paint one of his romantic realism paintings entitled,
The Mountains Declare His Glory.

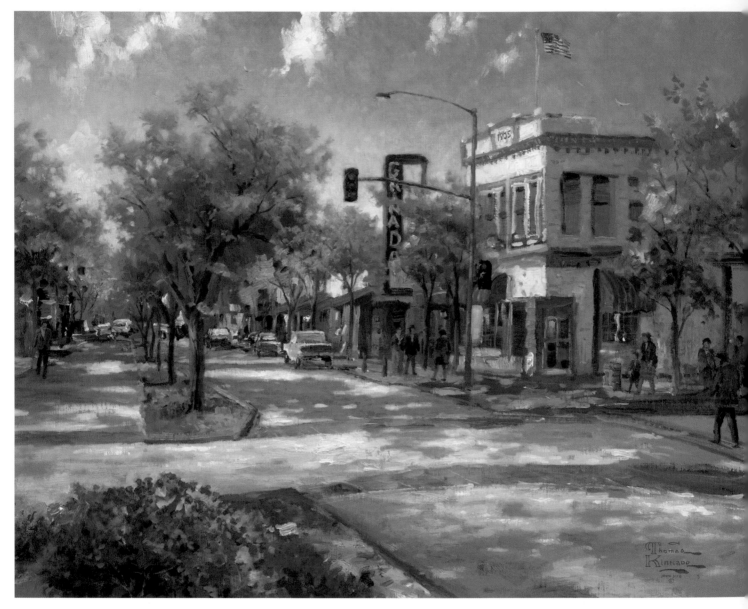

Morgan Hill: An All American Hometown, 2000
Oil on canvas, 23 1/2 x 29 1/2
Collection of Thomas Kinkade
Courtesy of the Thomas Kinkade Museum
and The Thomas Kinkade Company
Published: November 2000

This very large Plein air showcases a view of the main street
in Morgan Hill, California. Approximately 20 miles south of
San Jose, Morgan Hill is the home of Media Arts Group, Inc
and Lightpost Publishing—the publisher of Thomas
Kinkade's works.

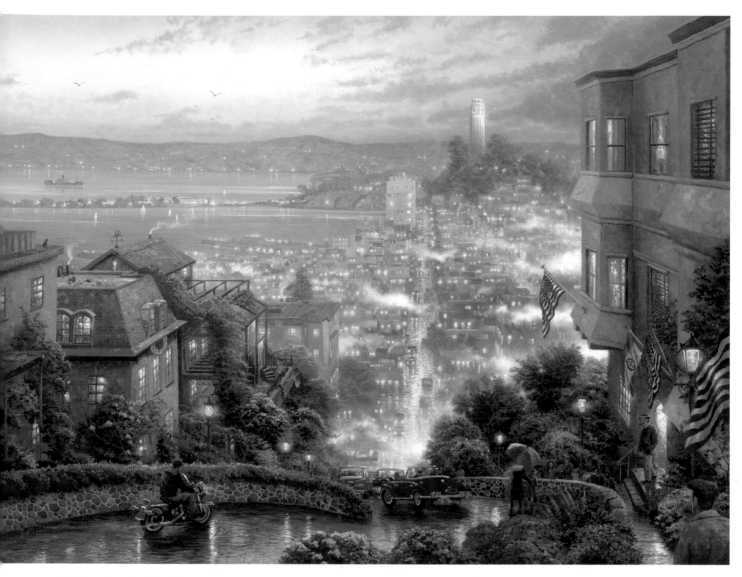

San Francisco, Lombard Street, c. 2001
San Francisco Series
Oil on canvas, 24 x 32
Collection of Thomas Kinkade
Courtesy of the Thomas Kinkade Museum
and The Thomas Kinkade Company
Published: December 2001

In the artist's own words—"Proclaimed 'the crookedest
street in the world,' Lombard Street plunges through a pro-
fusion of flowers and romantic old homes down by the bay.
Treasure Island, built as the larges manmade island in the
world for the 1939 Golden Gate International Exposition,
extends across the distant bay, and the sweeping spans of
the Bay Bridge, whose completion was the inspiration for
the fair, lies just beyond."

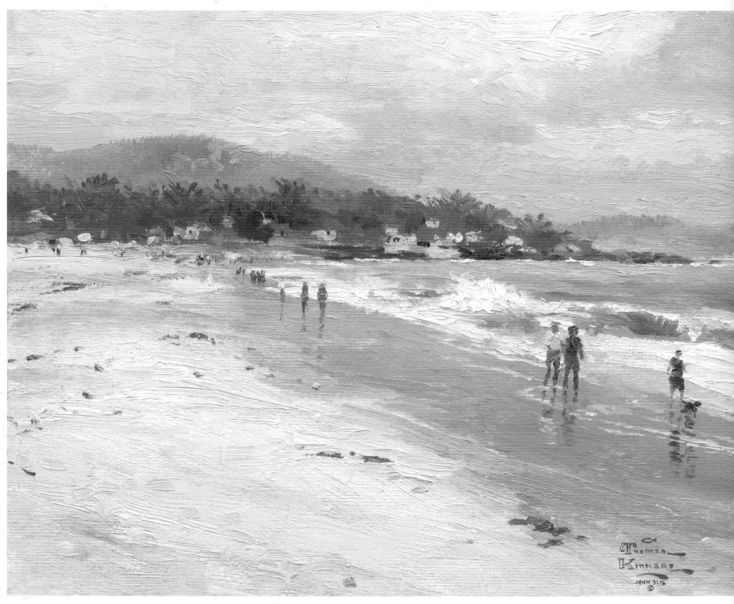

Carmel Beach, 1993
Oil on canvas, 8 x 10
Collection of Thomas Kinkade
Courtesy of the Thomas Kinkade Museum
and The Thomas Kinkade Company

Thom created this painting in November of 1993 on site. It
looked like the fog rolled in as Thom set up his easel and
painted this small work of art.

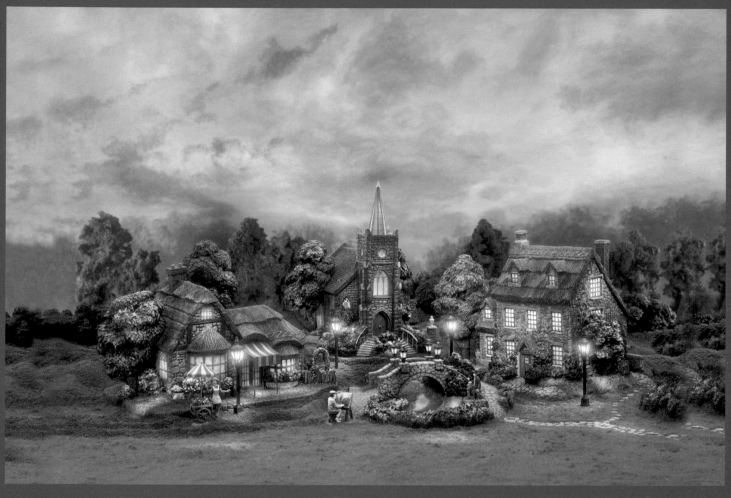

Lamplight Village
Falbrook Florist, Lamplight Bridge, Windermer Church and
Stonebrooke Inn
Ceramic collectable pieces
Gallery Marketing Group
www.gallerymarketinggroup.com

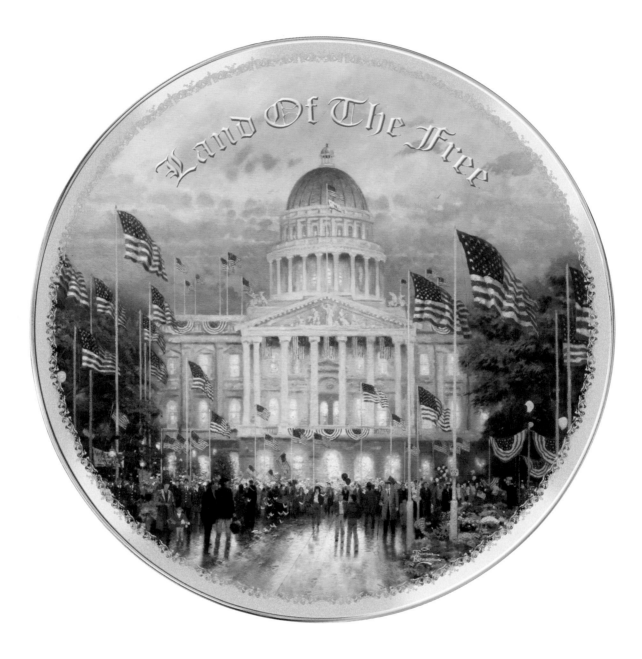

Flags over the Capital, God Bless America Series
Porcelain dish
Gallery Marketing Group
www.gallerymarketinggroup.com

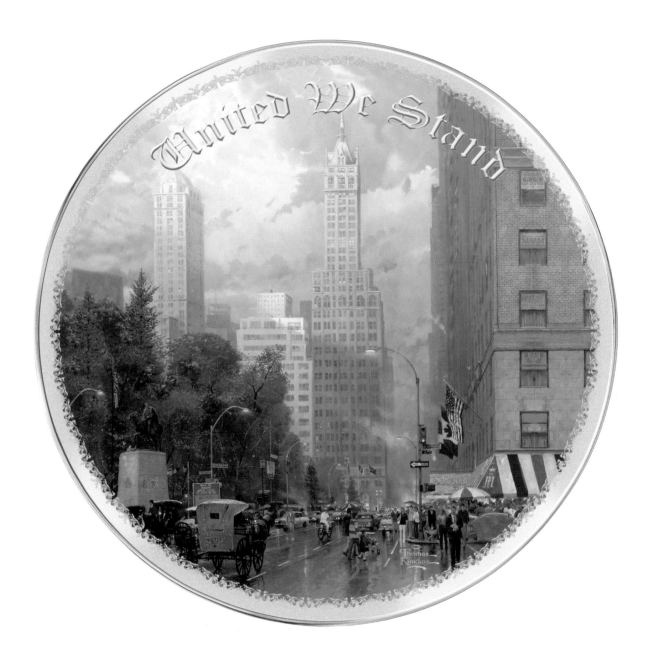

New York Central Park South, God Bless America Series
Porcelain dish
Gallery Marketing Group
www.gallerymarketinggroup.com

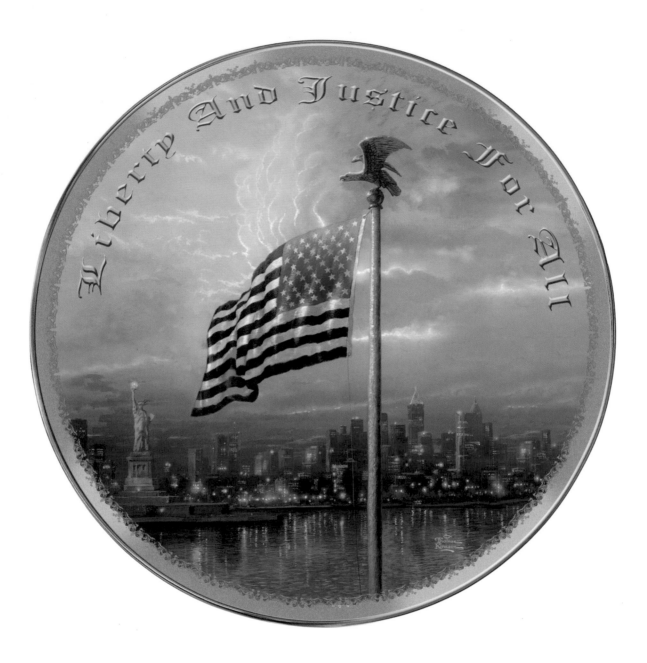

Lights of Freedom, God Bless America Series
Porcelain dish
Gallery Marketing Group
www.gallerymarketinggroup.com

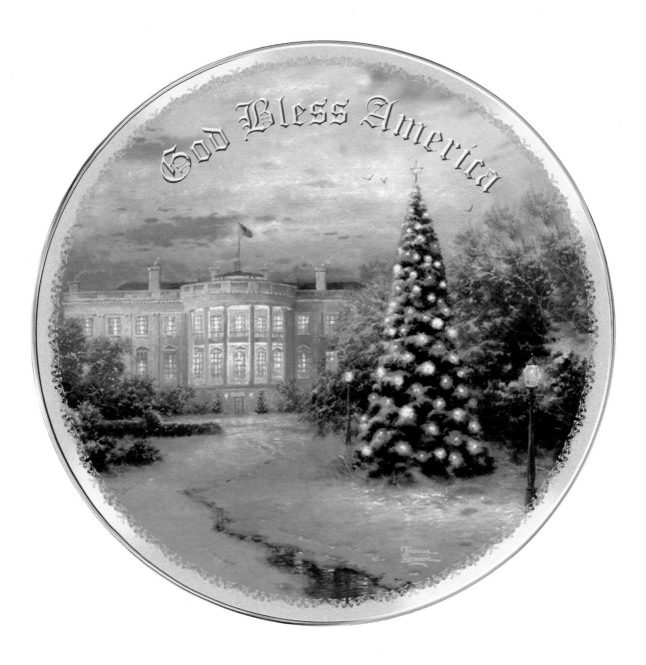

Lights of Liberty, God Bless America Series
Porcelain dish
Gallery Marketing Group
www.gallerymarketinggroup.com

Beyond the Spring Gate
Quilt
Candamar Designs
www.candamar.com

Light of Freedom
Woven throw blanket
Mohawk Home Goodwin Weavers Collection
www.goodwinweavers.com

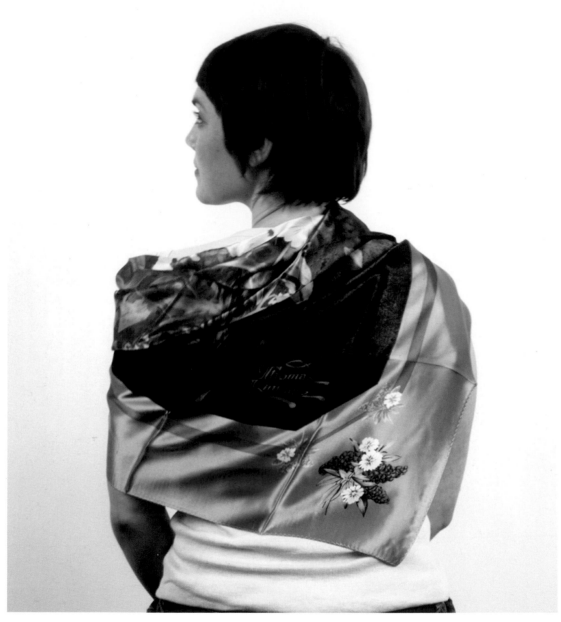

Lilac Bouquet
Silk scarf
The Thomas Kinkade Company
(formerly Media Arts Group Inc.)
www.thomaskinkade.com
Photo: M.O. Quinn

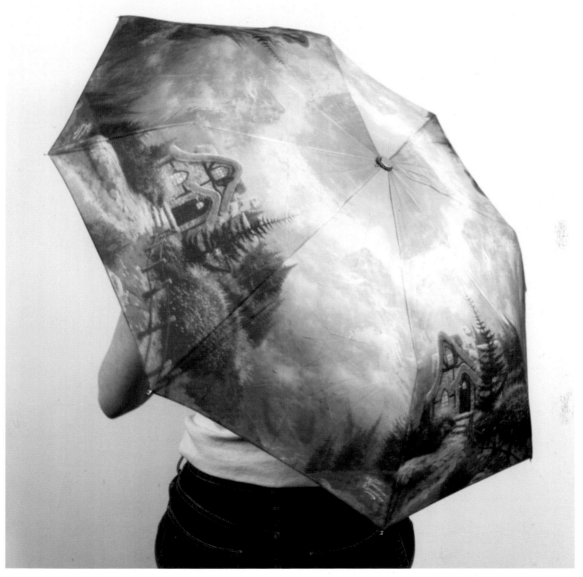

Sweetheart Cottage
Polyester umbrella with automatic opener
The Thomas Kinkade Company
(formerly Media Arts Group Inc.)
www.thomaskinkade.com
Photo: M.O. Quinn

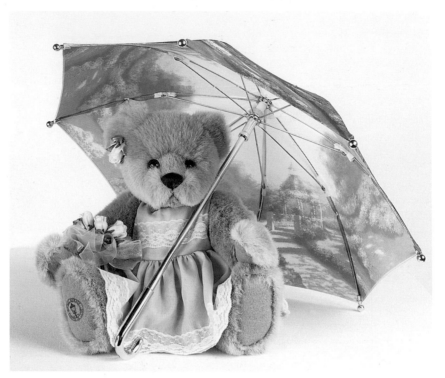

Flora &Her Garden Umbrella
Umbrella and teddy bear
Gallery Marketing Group
www.gallerymarketinggroup.com
Photo: M.O. Quinn

The combined artistry of Thomas Kinkade and Vickey Lougher make this a unique collectible. Thomas Kinkade's popular artwork, *The Hidden Gazebo,* decorates the working umbrella. Flora is 9" high, seated. Open umbrella measures 19" deep x 13" high.

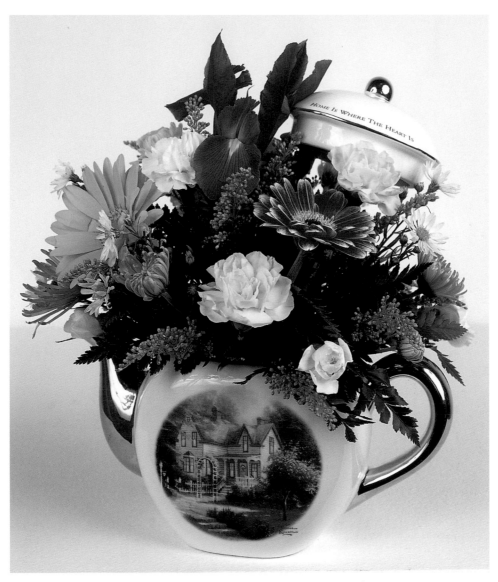

Home Is Where The Heart Is
Ceramic teapot and floral arrangement
Teleflora design, www.teleflora.com
Private Collection
Photo: M.O. Quinn

THOMAS KINKADE
Painter of Light™

DISPLAY EASEL & PUZZLE GLUE INCLUDED

FRAME IS PART OF THE PUZZLE
PUZZLE SIZE 9"X 7" · EASEL SIZE 4" X 5⅛" IN"

MINI *Master*™ SERIES
100 PIECE JIGSAW PUZZLE

Above: *Thomas Kinkade Mini Master Series Puzzle*
Right: *Sight and Sound Morning Dogwood Puzzle*
Puzzle in box
Ceaco Inc.
www.ceaco.com

THOMAS KINKADE
Painter of Light™
Sight & Sound

750 Pc. Puzzle
MUSIC CD

Morning Dogwood

*Enjoy this puzzle while listening
to hundreds of wild birds singing in unison.*

750 Piece Puzzle
with Nature & Music CD
Puzzle Size 24" x 18"

Two Compact Disks
Sight and Sound Morning Dogwood Puzzle
Ceaco Inc.
www.ceaco.com

Kinkade playing cards
Cards with box
U.S. Playing Cards
www.usplayingcard.com

Thomas Kinkade Watch Ad
Three designer wrist watches
The Advanced Group Inc.
www.advancegroupinc.com

Kinkade's Daily Gifts from God
Porcelain dish set and display with calendar
Gallery Marketing Group
www.gallerymarketinggroup.com

America the Beautiful
Limited edition porcelain plate
Gallery Marketing Group
www.gallerymarketinggroup.com

Thomas Kinkade Lightposts for Living
The Art of Choosing a Joyful Life
Time Warner Book Group
www.timewarner.com

The Thomas Kinkade Story
A 20 Year Chronology of the Artist
Time Warner Book Group
www.timewarner.com

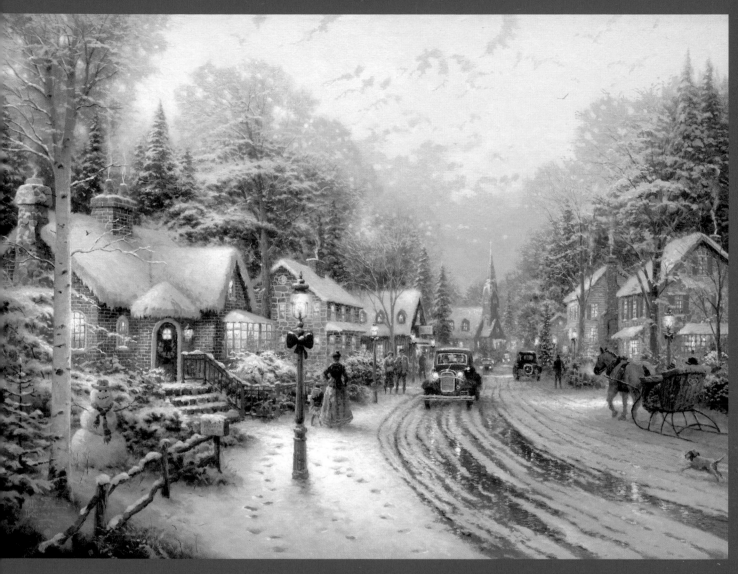

Village Christmas, 1997
Christmas Cottage Series
Oil on canvas, 18 x 24
Collection of Thomas Kinkade
Courtesy of the Thomas Kinkade Museum
and The Thomas Kinkade Company
Published: November 1997

Thom spent over 220 studio hours painting this detailed work and used items from his house for this work. The horse drawn sleigh featured is taken from an actual model sleigh that is used in their home to store the children's books.

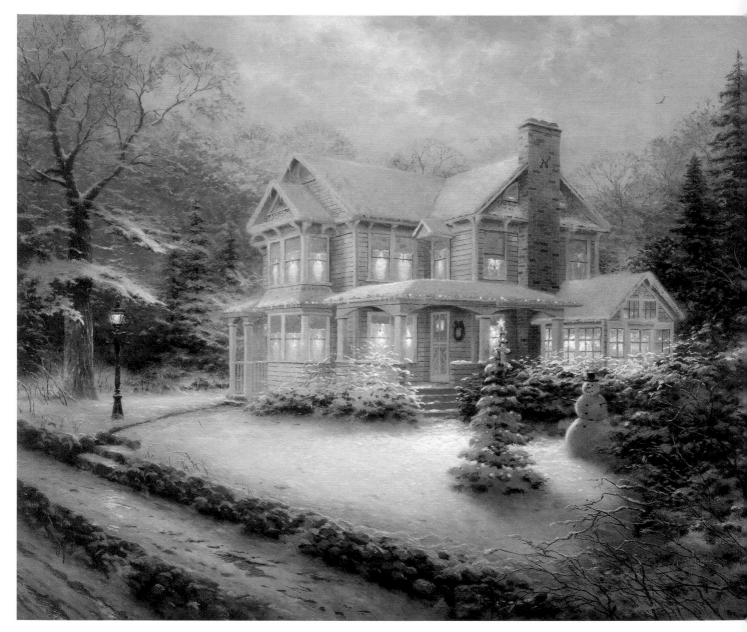

Placerville, Victorian Christmas III, 1993
Victorian Christmas Series
Oil on canvas, 20 x 24
Collection of Rick & Terri Polm
Courtesy of the Thomas Kinkade Museum
and The Thomas Kinkade Company
Published: September 1994
Title: *Victorian Christmas III*

The Victorian illustrated in this painting is based upon a real
bed and breakfast in Placerville, California—Thom's hometown.
The actual name of the house is the Chichester-McGee
House. Thom said, "The silence that graces this lovely
Victorian home is the same profound peace that once
enfolded a babe in Bethlehem."

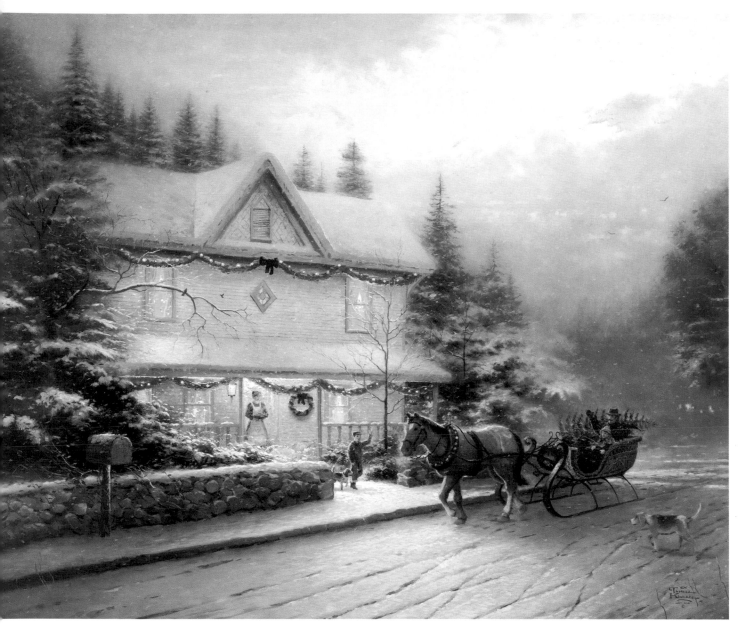

Placerville, Victorian Christmas IV, 1994
Victorian Christmas Series
Oil on canvas, 20 x 24
Collection of Rick & Terri Polm
Courtesy of the Thomas Kinkade Museum
and The Thomas Kinkade Company
Published: June 1995
Title: *Victorian Christmas IV: Bringing Home the Christmas Tree*

Based upon a real place in Placerville, California, its current
owner has converted this Victorian to a business office. In
Placerville, the house featured in this painting is right across
the street from the house featured in Victorian Christmas I.

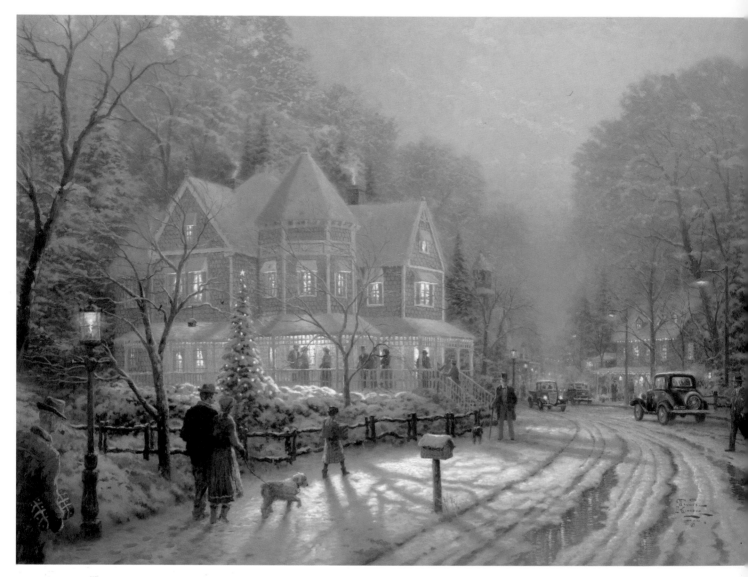

A Holiday Gathering, 1998
Christmas Cottage Series
Oil on canvas, 25 1/2 x 34
Collection of Thomas Kinkade
Courtesy of the Thomas Kinkade Museum
and The Thomas Kinkade Company
Published: March 1998

This classic painting is yet another example of Thom using people he loves and admires as models. The left-hand corner features Norman Rockwell bearing a gift. Just ahead are Thom and his wife Nanette walking a dog while his daughter Merritt holds the present. This nostalgic scene displays vintage cars and the town's folk gathering for a neighborhood celebration. Thom likes to think that this is a "Norman Rockwell Christmas—warm, welcoming, traditional."

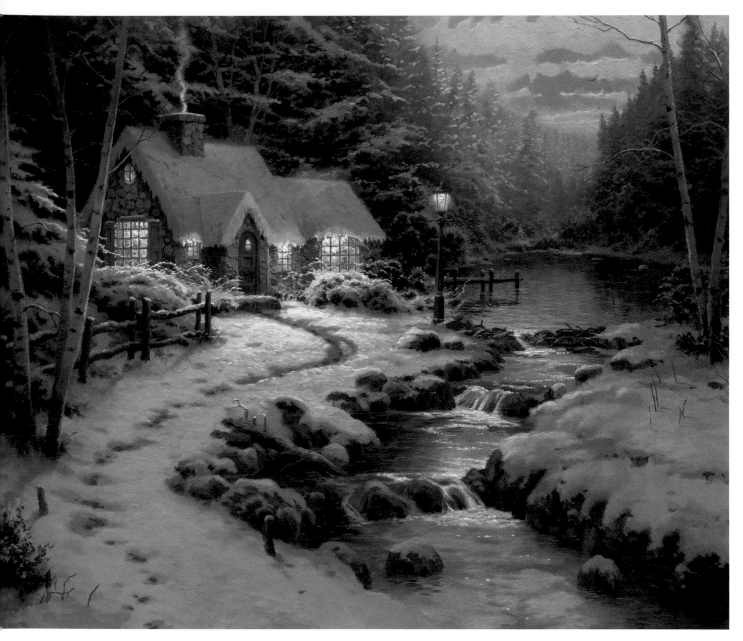

Evening Glow, 1999
Christmas Cottage Series
Oil on canvas, 16 x 20
Collection of Thomas Kinkade
Courtesy of the Thomas Kinkade Museum
and The Thomas Kinkade Company
Published: August 1999

The painting, *Evening Glow,* is a peaceful and tranquil scene.
Thom has placed 10 Ns (the number 10 for the 10th work in
the series and the letter N for his wife Nanette). The fence in
this work was inspired by Thom's neighbor's wooden fence.
The time of the painting is set at dusk, and the light post is
welcoming people into their home.

Christmas Express
Train set with oval track display
Gallery Marketing Group Inc.
www.gallerymarketinggroup.com

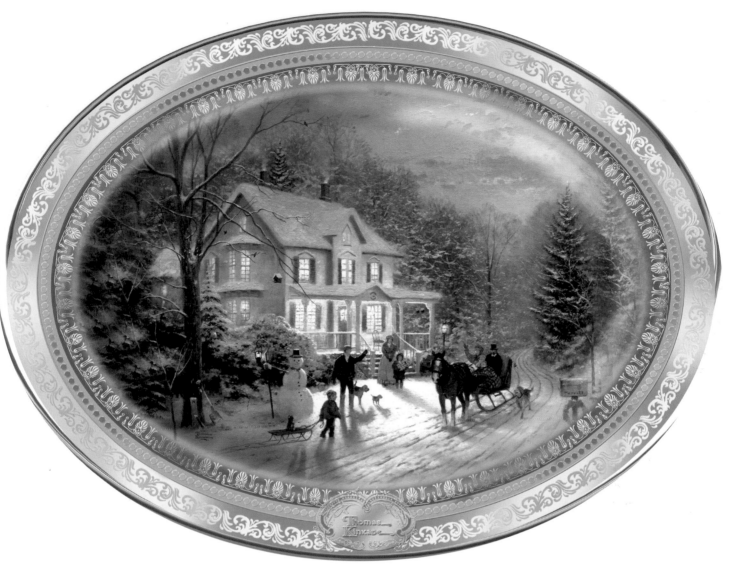

Home for the Holidays
Mantel Plate
Gallery Marketing Group Inc.
www.gallerymarketinggroup.com

Illuminated Holiday Ornaments
Victorian Christmas I&III
Holiday Gathering
Gallery Marketing Group Inc.
www.gallerymarketinggroup.com

Shoreline Splendor Ornaments
Clearing the Storm, Conquering the Storm
and *The Light of Peace*
Gallery Marketing Group Inc.
www.gallerymarketinggroup.com

Cherished Christmas
Music box
Plays *I'll be Home for Christmas*
Gallery Marketing Group Inc.
www.gallerymarketinggroup.com

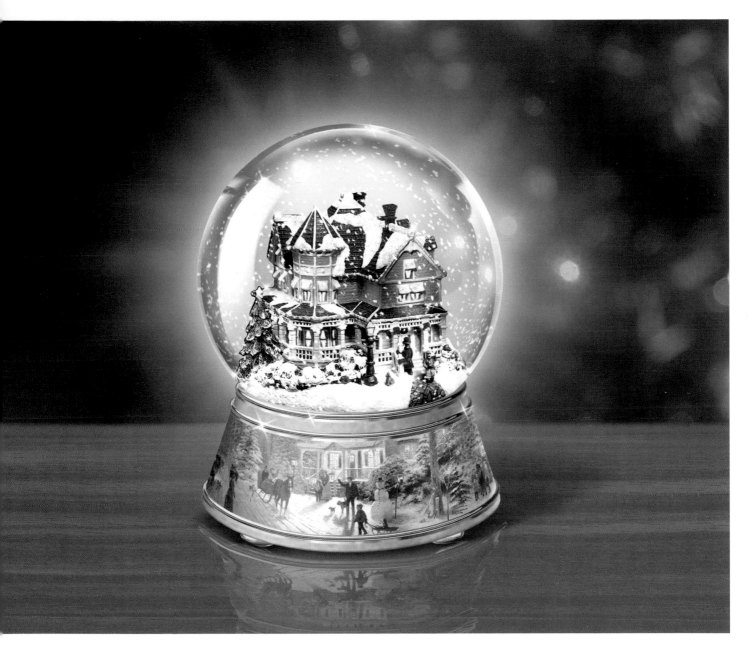

Winter Wonderland Music Box
Snow globe
Plays *White Christmas*
Gallery Marketing Group Inc.
www.gallerymarketinggroup.com

The Light of Saint Nicholas, Hamilton
Ceramic Sculpture
Gallery Marketing Group Inc.
www.gallerymarketinggroup.com

Thomas Kinkade "Painter of Light"
Premium Assorted Chocolates
Rocky Mountain Chocolate Factory
www.rmcf.com

Above: Home for the Holidays
Right: Sunday Evening Sleigh Ride
Greeting Card
Pop Shots

Holiday Gathering
Framed embroidery
Candamar Designs
www.candamar.com

Victorian Christmas
Tapestry
Candamar Designs
www.candamar.com

Christ, the Light of the World
A Devotional book
Thomas Nelson Inc.
www.thomasnelson.com

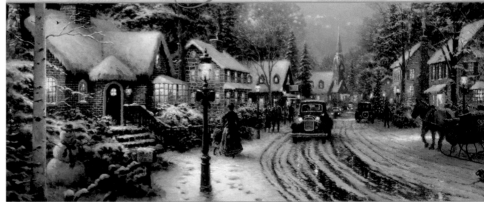

A Village Christmas
Personal Family Memories and Holiday Traditions
Thomas Nelson Inc.
www.thomasnelson.com

Kinkadescapes Volume 1 – Winter
A Winter Celebration
Video with Holiday Music
The Thomas Kinkade Company
(formerly Media Arts Group Inc.)
www.thomaskinkade.com

The Best of Christmas
and Christmas Favorites
Compilation CD's
Madacy Entertainment
www.thomaskinkade.com

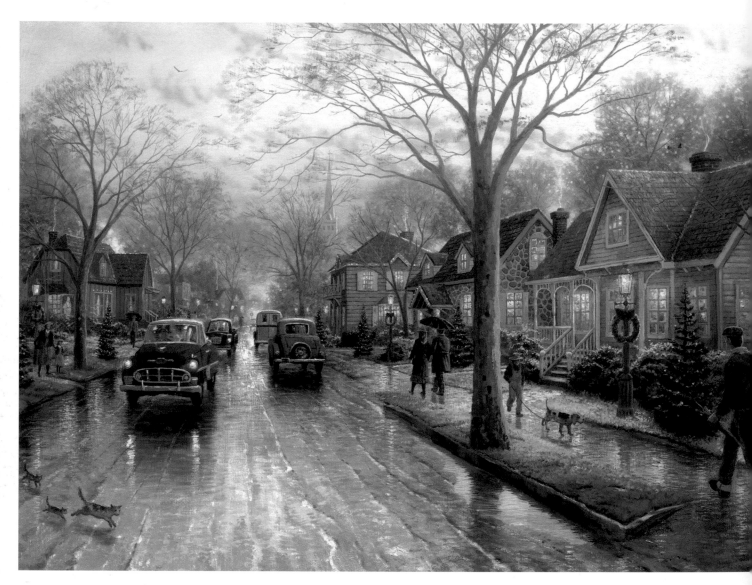

Hometown Christmas, 2002
Hometown Christmas Series
Oil on canvas, 18 x 24
Collection of Thomas Kinkade
Courtesy of the Thomas Kinkade Museum
and The Thomas Kinkade Company
Published: September 2002

In the artist's own words—"I've chosen to honor this warmly American institution by portraying a hometown that I hope reminds you of your own during that pre-eminent celebration of home and family—the Christmas season. *Hometown Christmas* is not a snow scene, because many of the Christmases I most enjoyed growing up were not blessed with snow. They were, however, charmed by the warmth of hearth and home."

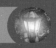

The Prince of Peace, c. 1980
The Archive Collection
Oil on canvas, 18 x 14
Collection of Mary Anne Kinkade
Courtesy of the Thomas Kinkade Museum
and The Thomas Kinkade Company
Published: March 1999

In the artist's own words—"How true this was for me in 1980 when, as an art student, I came to have a personal relationship with Christ. Just a few weeks later, awash in my newfound faith, I found myself sitting in an art class, my mind wandering. As I went though the motions, my eyes on the disinterested model posing for class, I was suddenly struck with a powerful vision. The vision that was laid on my heart that day is the painting you see before you, *The Prince of Peace.*"

Wallpaper detail
Pre-pasted peelable vinyl
Thomas Kinkade Painter of Light Volume 2
Imperial Wall Décor
© Imperial
www.ihdg.com

Rev. Ethan Acres

The farmhouse spins like a dervish as it falls from the colorless sky. With a crash it strikes the earth, and its two occupants, a young girl in pigtails and bows, and her little dog, too, are pitched forward off the bed. She slowly stands up, gathering the little dog into a basket, and wanders through the wrecked house. Fear grips her heart as she reaches for the door, but nonetheless she grips the knob firmly and turns. As the door swings silently open, a brilliantly colorful light illuminates the room and the girl, Dorothy, wanders out into …

… Munchkinland. Yes, Beloved, that was what popped into my noodle the very first time I saw one of Thomas Kinkade's prints. I had returned home to Haleyville, Alabama (that's about 45 minutes due south of Muscle Shoals, for all you Southern Rock aficionados), happily taking a break from the University of Texas at Austin where they were "learning me" how to become a failed painter. And very successfully, I might add. Within moments of dismounting my steel horse, one 1993 Honda Magna, *Praise God,* my mom had whisked me inside and happily retreated to the kitchen to make me my favorite, a pimento loaf and Miracle Whip sandwich nestled in a lovely bed of Pringle's potato chips. Yum, yum.

So, there I was, your humble preacher, standing in my mother's cozy little living room, just innocently looking around, when … BAM! Suddenly, my eyes were sucked into a vortex of baby blue and coral pink that issued forth from the space on the wall where previously had hung my high school graduation photograph. Teetering over the old couch on which, a long time ago and in a galaxy far, far away, I had had my very first kiss, I stared deeply into the image of a little house immersed in an overflowing garden of flowers that in no way, shape or fashion could exist within this space-time continuum. Now, friends, I would be one dirty dog liar if I stood here before you and said that the first emotion that burned in my heart at that moment wasn't sadness. I mean, come on, that graduation photo was the only picture of me from high school that didn't look like an image brought back from one of the Apollo moon missions. But all that sadness, my lambs, was quickly sopped up like milk in cornbread by something else. Curiosity. For I cannot deny that I was strangely attracted to the little picture. That's right, friends, I said strangely attracted, for, please, tell me, how could a junior in the Fine Arts program of U.T. Austin, only thirty credits away from the crowning achievement of earning his, let's say it together with lots of spirit, sports fans, *BEE EFF EHHHH,* possibly like a picture such as this, with its tender subject matter all wrapped up in a

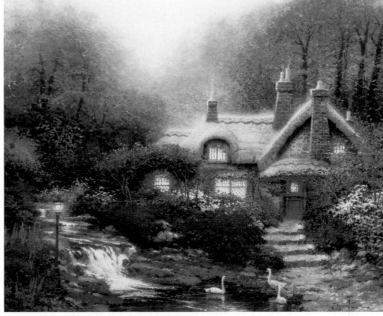

Evening at Swanbrooke Cottage, Thomashire, 1991
Oil on canvas, 24 x 30
Private Collection of Rick & Terri Polm
Courtesy of the Thomas Kinkade Museum
and The Thomas Kinkade Company
Published: January 1992

package of happy colors and Walt Disney lighting? But, somehow, for some reason, I did. At that very moment of reflection, I almost jumped out of my skin when my mother, oh she of the very pointy nails, poked me in the back.

"Come on in the kitchen and eat your…Oh, hey, I see you've discovered my most recent acquisition, hee hee."

"Yeah," I sheepishly replied, "It's…well…Honestly, part of me wants to hate it, but, oh hell, I don't know. It's really weird, Mom."

She pinched my arm. "Don't swear, Ethan. People will think you have a dull mind. And I don't think it's weird at all, Mr. High and Mighty. I think it's beautiful. I think maybe Heaven looks like that."

"Or maybe Oz."

"Oh, Quit being so darned silly, and git to the table, professor…" she shrilled as she gently nudged me in the direction of the door. But, for a brief moment something registered on her face. Something like euphoria. I wasn't alone. She had felt it too. That picture somehow meant something to both of us. It resonated. Perhaps, as she had said, it truly was a vision of Heaven. Very soon, I would come to know the truth.

· · · · ·

Now, children, the Bible doesn't go into a lot of specifics about what Heaven may look like. So, for the last two millennia, men and women far more knowledgeable than yours truly have attempted to describe Heaven. Over the years, many of their theories have become deeply ingrained in the popular consciousness. In the early medieval period, the most popular belief, as one may read in the *Elucidation,* a widely used monastic manual compiled in Latin around 1100, was that after the Last Judgment, God will remove all consequences of the Fall: "The punishment for sin: that is, coldness, heat, hail, storm, lightning, thunder, and other inconveniences [tornadoes, possibly?] will utterly disappear." The monks proposed that the new creation, Heaven, will be a fragrant, pleasant garden, where the blessed, restored to nakedness like innocent children, may frolic and play eternally within a landscape decorated with sweet-smelling flowers, lilies, roses, and violets, that will never fade. This is a world totally lacking in toil and pain. A new Eden. However, this popular belief would change over time, for the simple reason that by the twelfth and thirteenth centuries, Europe was experiencing an urban revival. While rural life still dominated the countryside, between 1150 and 1250 the number of towns in central Europe increased from about 200 to 1500. And, even though this emerging urban culture never represented more than five percent of the total population, it still had the greatest impact on society as a whole. Think about it, my lambs, think how the flourishing cities with their magnificent high walls, their towers and cathedrals, their busy marketplaces, workshops, and luxurious houses, just imagine how someone from the farmland must have felt when first they walked one of these streets. If you find

Kinkade Nativity
Porcelain figurine set
Gallery Marketing Group, Inc.
www.gallerymarketinggroup.com

Thomas Kinkade Chapel
Sunday Evening Sleigh Ride
Tabletop Sculpture and floral arrangement
Teleflora, www.teleflora.com

this difficult, simply remember the first time you walked down the streets of New York or Paris, and perhaps you can empathize. In the melting pot of the cities, as money and piety blended, modern Christianity was born. For it was money that built the cathedrals, supported the crusades, financed the charities … and through money the townspeople could build a life for themselves in which they could have the most precious gift of all: time. Unlike their country cousins, who had to spend every waking moment simply trying to survive, the townfolk, sleeping peacefully behind their great stone walls, a short walk from their markets, a stone's throw from whatever passed in the Middle Ages for their equivalent Starbucks, could spend all their extra time thinking about the Divine nature of the Universe. But, of course, they needed direction. But who? Monks previously had lived like ascetics, staying largely away from the population as a whole.

In order to meet the spiritual needs of all these people with so much free time on their hands, the mendicant orders of Franciscan and Dominican friars were formed. These orders allowed their members to live a life of chastity, poverty and obedience as prescribed by monastic tradition, but, at the same time, they worked in the world, thus functioning as contributing members of society. Thus, the ascetics no longer withdrew from society, but thronged into the cities. And as they became cityfolk, it became hypocritical of them to say that all things bright and shiny, all things luxurious, were bad, and, accordingly, religious thought slowly changed. It grew and became palatable to a hegemony that wanted a world where, understandably the high and middle classes would never be buddies, but they would at least tolerate each other. In order to facilitate this new vision, the friars began to promote an urban concept of Heaven, one that gave prominence to culture over nature. They thus turned from the first pages of the Bible to the last … from Eden to New Jerusalem, as described in Rev. 21. "And the building of the wall of it [the city] was of jasper, and the city was pure gold, like unto clear glass. And the foundations of the wall of the city were garnished with all manner of precious stones. The gates were like pearls, and the streets of the city were pure gold."

Even in the liturgy of the church, one was told of the urban hereafter. "May the angels lead you to paradise," sang the priests, "may the martyrs welcome you when they arrive, and may they guide you to the holy city of Jerusalem." The liturgy, some form of which had been chanted since the ninth century, basically suggested that, yes, when you rise up from the earth and enter Heaven, first you wander through a lovely garden, but, then, you enter the Holy City. This idea fueled a host of people who took up this idea of Heaven as Metropolis. Peter Abelard (1079—1142), Joachim of Fiore (1132—1202), Gottschalk of Holstein (d. 1066) all began describing in essays, in poems, the straight avenues and regularly arranged houses of heavenly Jerusalem. Gerardesca (1210-1269), a woman tertiary of the Camaldolese order, went so far as to map out in fine detail, Heaven. She proposed that Heaven was a city-state with a vast park-like territory. Gerardesca distinguished three areas in which the blessed live: the city itself (New Jerusalem), seven castles built on mountains encircling the city, and numerous minor fortresses in the

vicinity. The city proper would be the abode of the Trinity, the Virgin Mary, and the choirs of angels and the holiest saints. In the seven castles live those of the blessed who may not be saints but still deserve perks for all the good work they did before Armageddon. (She believed that, three times a year, the entire Heavenly Court would visit these Castles.) And lastly, the minor fortresses would be the homes of the rest of the blessed. However, the land surrounding the city would be unpeopled, for there of course would be no peasants. Gerardesca's vision of Heaven was not a world of equality, but it was a vision of eternal peace and human structure.

· · · · ·

As I sat there at the table, eating my pimento loaf sandwich, the fluffy bits of Wonder Bread virtually melting on my tongue like the Host, I tried and tried to figure out exactly what was so exciting about that picture, that Kinkade. Why did it make me feel so …? Well, the only word I can use to describe the sensation is safe. As I looked across the table at my mother, smoking her Virginia Slims, I remembered. Oh brothers and sisters, oh yes, I remembered the countless times as I grew up, sitting next to her on that beaten up old sofa, watching *The Wizard of Oz* together, just the two of us. I remember the smell of her favorite perfume, Charlie, and the way the smoke from her cigarette would slowly drift around the room. I remember that thrill I got each time Dorothy got up from her bed, crossed her black and white room, and opened the door into that electric Technicolor extravaganza called Oz. And, most of all, sitting there with my mom, college boy, cynic, Mr. High and Mighty himself… I remembered joy. I remembered Home.

Many years have passed … I don't think my mom still has the Kinkade, but you see, gentle listeners, I don't believe she needs it any longer, for she has finally found her Emerald City. I know more about Thomas Kinkade now, I suppose. I know why the images resonate in the hearts and minds of so many people. The Painter of Light™, in his vast body of work, is giving people, much as did Gottschalk of Holstein, Peter Abelard, Joachim of Fiore, and all those monks, a vision of Heaven. Not the Metropolis that Gerardesca described in painstaking detail, and not the Garden of debauched peasants as dreamed of in the *Elucidation*. No… Kinkade paints a picture of the Heaven of Middle America. In much the same way that L. Frank Baum cre-

Almost Heaven
Woven throw blanket
Mohawk Homes Goodwin Weavers
www.goodwinweavers.com

ated in *The Wizard of Oz* an Americanized fairy tale, combining pixies, talking animals, and witches, with scarecrows, mechanical woodsmen, and traveling carnies, so has Kinkade taken the timeworn visions of the Heavenly Garden and Eternal City and founded a middle ground, Heaven's suburbs, if you will. Christ said in John 14:2, "In My Father's house are many mansions." Kinkade, in paintings such as *A Quiet Evening, Autumn at Ashley's Cottage, Hollyhock House, Brookside Hideaway…* the list goes on and on, presents the viewer time and time again with sublime images of little homes out in the country, all glowing from the inside with a light that could never be cast by simple lanterns or candles. No, my friends, the glow that illuminates the windows of Kinkade's little world is the electric Technicolor of Oz. Each of these paintings depicts just one of the many, or should I say mini, mansions Christ has prepared in the Garden for each of us, and the sheer number of images that Kinkade has produced already, in a career that has spanned just a few decades (not even taking into account the number of images circulating out in the world thanks to the almost limitless editions), seems to promise that, yes, in Heaven there will be room for us all. Doubt not Thomas, my friends, for through his vision we may all travel over the rainbow, and there find everlasting peace. Amen.

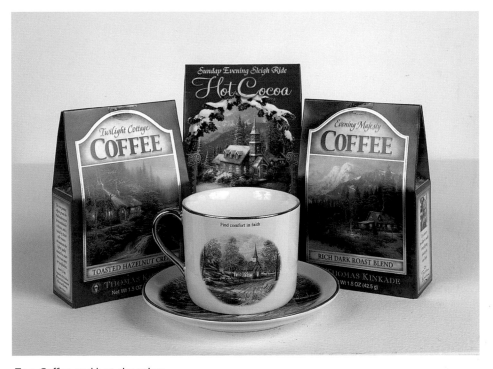

Top: Coffee and hot chocolate
Brownlow Corp.
Photo: M.O. Quinn

Center: *Find Comfort in Faith*
Coffee cup and saucer
Teleflora
www.teleflora.com

The Reverend Ethan Acres lives in the City of Angels with his beautiful wife Lisa, his son Cyrus, and their trusty dog Achilles. He fights to defeat the devil in all his evil forms, and strives to put the "fun" back in "fundamentalism."

The Forest Chapel, 1999
Chapels of Nature Series
Oil on canvas, 25 x 30
Collection of Thomas Kinkade
Courtesy of the Thomas Kinkade Museum
and The Thomas Kinkade Company
Published: August 1999

Thom has said that this painting "portrays a daydream" he
has had so many times—"a wonderful place to worship
God." In this work, he has captured his idyllic spot to pray—
"a chapel in an unspoiled natural setting." Thom has a passion
for combining two of his favorite themes in one painting—
his love of nature and God. This image is the first time Thom
has painted stain glass windows in a chapel.

Streams of Living Water, 2000
Chapels of Nature Series
Oil on canvas, 30 x 40
Collection of Thomas Kinkade
Courtesy of the Thomas Kinkade Museum
and The Thomas Kinkade Company
Published: December 2000

In the artist's own words, "There are scenes in nature so
graciously constructed, so sublime, that they become, in
essence, parables in wood and water and stone. The duty of
the artist is to witness with a loving heart and record with a
sure hand and truthful eye. That is what I hope I've done in
Streams of Living Water, a scene where God allows us to
glimpse His loving kindness."

The Mountain Chapel, 1998
Chapels of Nature Series
Oil on canvas, 30 x 24
Collection of Thomas Kinkade
Courtesy of the Thomas Kinkade Museum
and The Thomas Kinkade Company
Published: March 1998

Although the chapels Thom visited in the Rocky Mountains
region inspired him to paint this church, the mountain
range is unknown. This painting captures Thom's message
of a simple place to worship in majestic nature, a place
where man and nature meet as one.

Sunrise, A Prayer of Hope for the Millennium of Light, 1999
Oil on Canvas, 40 x 32
Collection of Thomas Kinkade
Courtesy of the Thomas Kinkade Museum
and The Thomas Kinkade Company
Published: December 1999

Although you do not see the sun, it is in the center of the
painting, a symbol for God—unseen yet the central part of
our lives. There are some references in this painting to the
Holy Trinity—three points on the cross and three ledges of
rock approaching the cross. The mountains in the paintings
are based upon a trip Thom took to the Hawaiian volcano,
Halenkala. If you look closely in the light of the sun, you can
see an image of a cross.

The Aspen Chapel, 2001
Oil on canvas, 24 3/8 x 36 1/4
Collection of Thomas Kinkade
Courtesy of the Thomas Kinkade Museum
and The Thomas Kinkade Company
Published: August 2001

The inspiration for this painting came to Thom while hiking
to Hope Valley in the Sierra Mountains. He spotted a grove
of golden aspens and thought that it would be an "idyllic
place for worship."

Pools of Serenity, 1999
The Garden of Prayer Series
Stained Glass
Glassmaster/OMNIA

The gazebo in this garden scene is based upon a real one
on the island of Maui in Hawaii. Some may not see the figure
standing at the end of the path on the left hand side of the
painting. Thom said, "This serene haven—a breathtaking mirror
bright pool reflecting an abundance of flowers, embraced by
the shelter of a monumental stone gazebo—expresses the
'peace that passeth understanding' that rewards my
communion with the divine."

I Am the Way, the Truth and the Life
Hands of Faith Series
Tabletop Sculpture
Gallery Marketing Group Inc.
www.gallerymarketinggroup.com

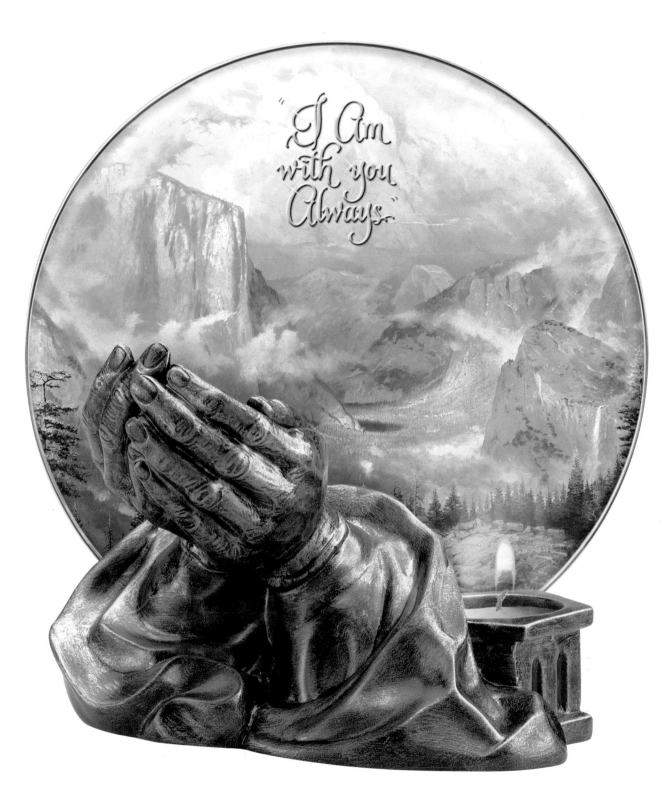

I Am With You Always
Hands of Faith Series
Tabletop Sculpture
Gallery Marketing Group Inc.
www.gallerymarketinggroup.com

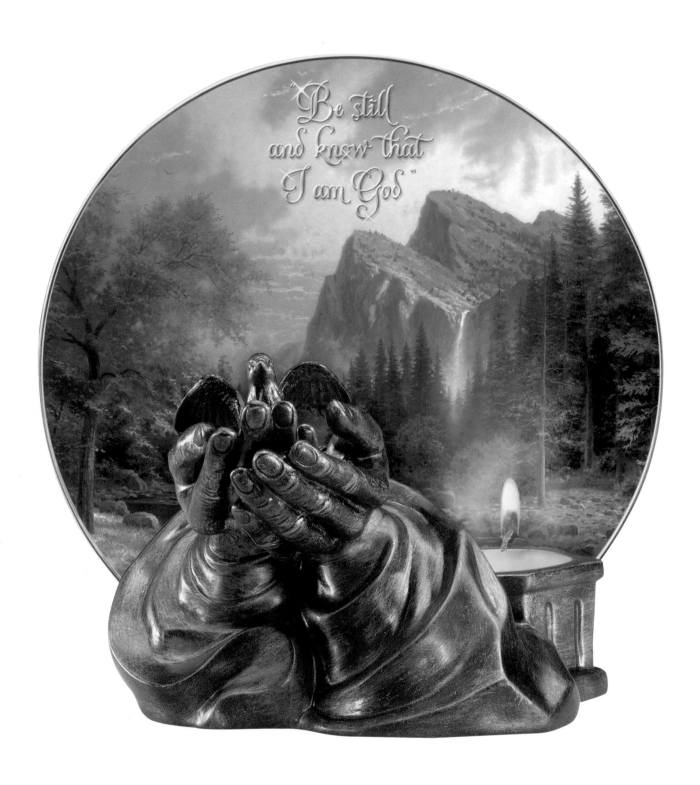

Be still and know that I am God
Hands of Faith Series
Tabletop Sculpture
Gallery Marketing Group Inc.
www.gallerymarketinggroup.com

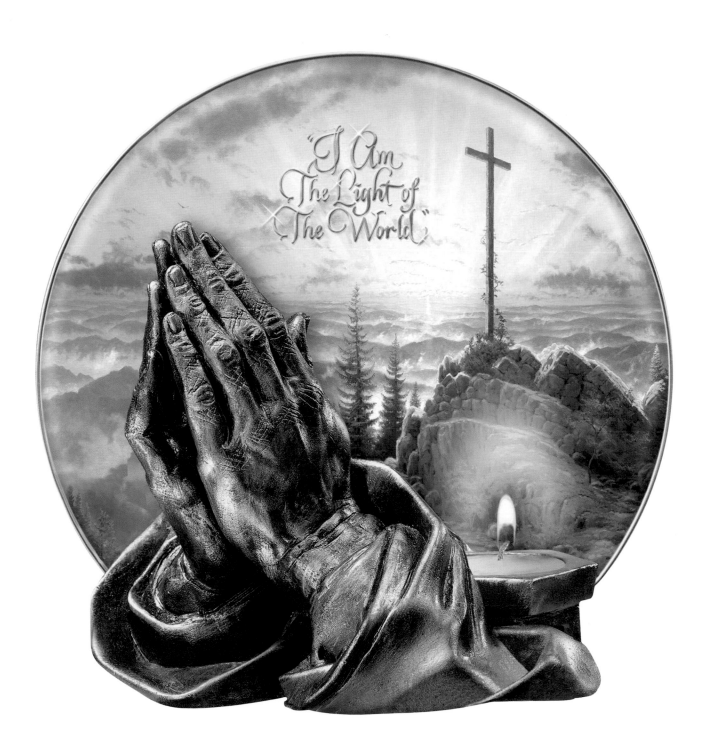

I Am the Light of the World
Hands of Faith Series
Tabletop Sculpture
Gallery Marketing Group Inc.
www.gallerymarketinggroup.com

The Garden of Prayer
Tabletop sculpture
Gallery Marketing Group Inc.
www.gallerymarketinggroup.com

Bride's Bible

Scripture Selections

and Reflections

by Thomas &

Nanette Kinkade

THOMAS KINKADE
Painter of Light™

Bride's Bible
Thomas Nelson Inc.
www.thomasnelson.com

Sunrise
Woven throw blanket
Mohawk Homes
Goodwin Weavers Collection
www.goodwinweavers.com

Sunrise pillow
Woven pillow
Mohawk Homes
Goodwin Weavers Collection
www.goodwinweavers.com

Moonlit Village pillow
Woven pillow
Mohawk Homes
Goodwin Weavers Collection
www.goodwinweavers.com

Bridge of Faith
Tote
Gregg Gifts
www.gregggiftcompany.com

Light of Peace
Embroidered Bible cover
Gregg Gifts
www.gregggiftcompany.com

Wallpaper Border
Pre-pasted peelable vinyl
Thomas Kinkade Painter of Light Volume 2
Imperial Wall Décor
© Media Arts Group Inc., Morgan Hill, CA
www.ihdg.com

THOMAS KINKADE
Painter of Light™
MESSAGES FROM THE HEART™
An Inspirational Card Game

"I am always *Imagining* a world of *Family* gatherings, of quiet time spent in the company of *Loved Ones*." – Thomas Kinkade

Messages from the Heart
An Inspirational Card Game
Game box
Ceaco Inc.
www.ceaco.com

True *Simplicity* begins when you learn to enjoy the amazing *Abundance* of what is already yours. - TK

A. Name 5 good things that you have - including possessions, good personal qualities, friendships, and family.
B. Is simplicity better than extravagance? Why?

Ah, the *Simple Life!* - TK

What does this quote mean to you?

A simple *Compliment* can be a profound *Blessing*. - TK

A. Tell us about a time someone complimented you and made you feel really good.
B. Pay a nice compliment to another player.
C. What might be a nice thing to say to a teacher? A dentist? A parent?

Love your home - its physical space, its personal history, the *Relationships* that define it. - TK

A. Name two ways to show you love your house and the people in it.
B. Tell us about your house. When did you move in? Who lived there before?
C. What is your favorite thing about your house?

Rejoice in the abundant *Blessings* that fill your life. And once again, say thank you. - TK

Think of an interesting and different way to say thanks for your blessings.

You put the *Light* in your windows by *Sharing* your life with others. - TK

A. Talk about two unlikely people who share a life.
B. Do you share your life with your family? What do you do together?
C. Tell us something you like to do with your friends.

Messages from the Heart
An Inspirational Card Game
Cards
Ceaco Inc.
www.ceaco.com

THOMAS KINKADE

A
MOTHER'S
TIMELESS WISDOM

INSPIRATION *for* YOUR JOURNEY

A Mother Timeless Wisdom
Thomas Nelson Inc.
www.thomasnelson.com

THOMAS KINKADE

Touched by the LIGHT

Touched by the Light
Thomas Nelson Inc.
www.thomasnelson.com

A Devotional

Perfect Peace and Rest

FEATURING *the* ARTWORK *of*

THOMAS
KINKADE

Perfect Place to Rest
Devotional book
Thomas Nelson Inc.
www.thomasnelson.com

Beside Still Waters
Devotional book
Thomas Nelson Inc.
www.thomasnelson.com

With Wings like Eagles
Devotional book
Thomas Nelson Inc.
www.thomasnelson.com

Light the Way Home
Four interconnecting candle holder pieces
on wooden base with flower arrangement
Gallery Marketing Group Inc.
www.gallerymarketinggroup.com

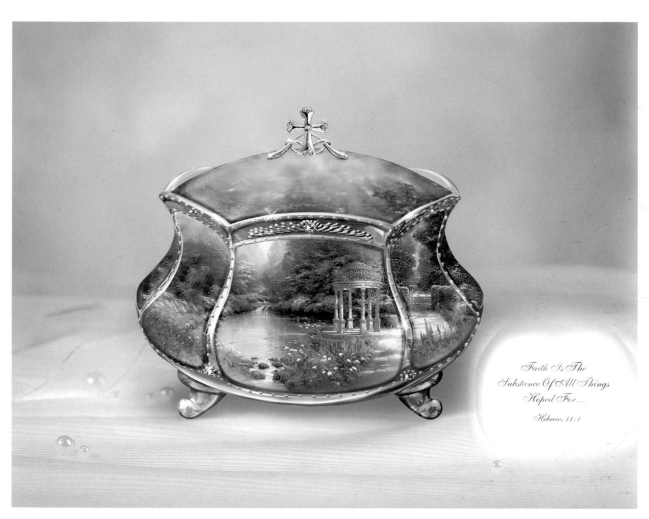

Have Faith Music Box
Plays *You'll Never Walk Alone*
Spiritual Garden Series
Gallery Marketing Group Inc.
www.gallerymarketinggroup.com

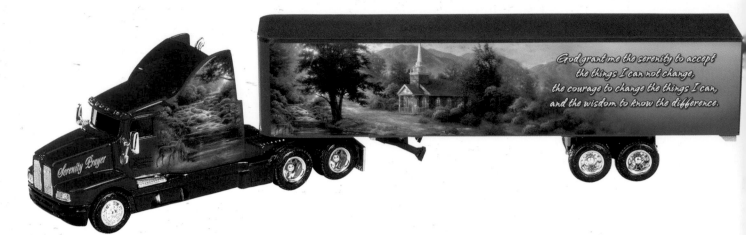

Serenity Prayer
Thoughts for the Road
Rolling wheels with chrome and detachable trailer
Gallery Marketing Group Inc.
www.gallerymarketinggroup.com

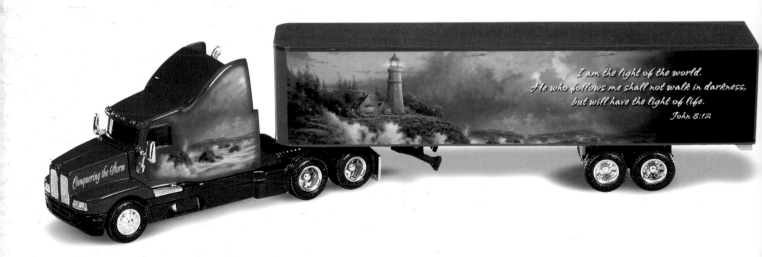

Conquering the Storm
Thoughts for the Road
Rolling wheels with chrome and detachable trailer
Gallery Marketing Group Inc.
www.gallerymarketinggroup.com

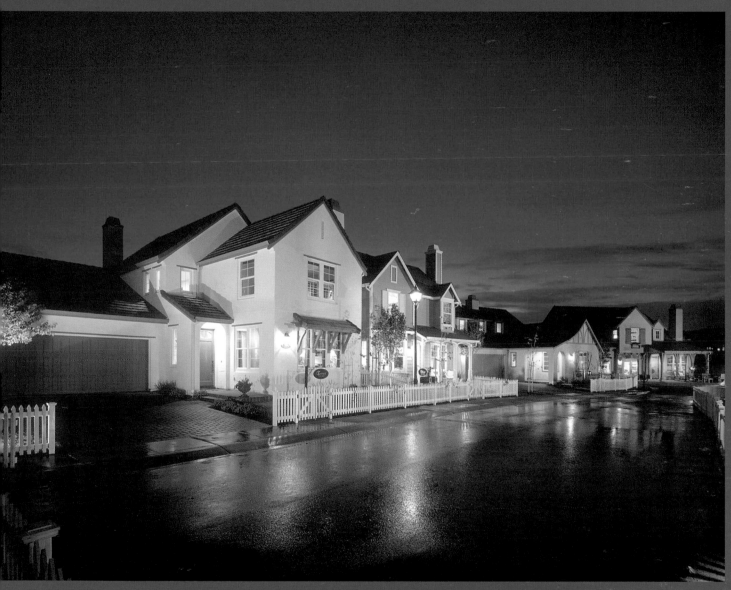

Street Scene
The Village at Hiddenbrooke
Taylor Woodrow Homes
William Hezmalhalch Architects Inc.
Photo: John Bare Photography

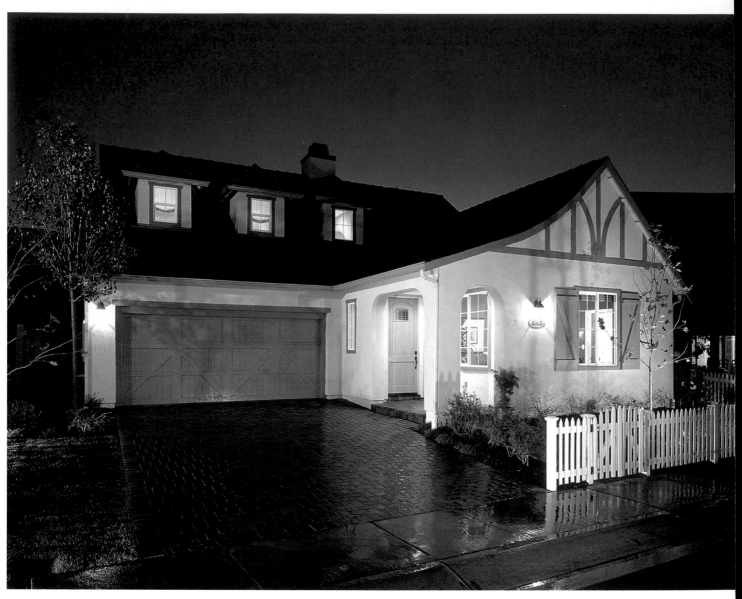

Above: Plan 1 Exterior
Right: Plan 1 Inspirational Drawing
The Village at Hiddenbrooke
Taylor Woodrow Homes
William Hezmalhalch Architects Inc.
Photo: John Bare Photography

Inspirational drawing
The Village at Hiddenbrooke
Taylor Woodrow Homes
William Hezmalhalch Architects Inc.

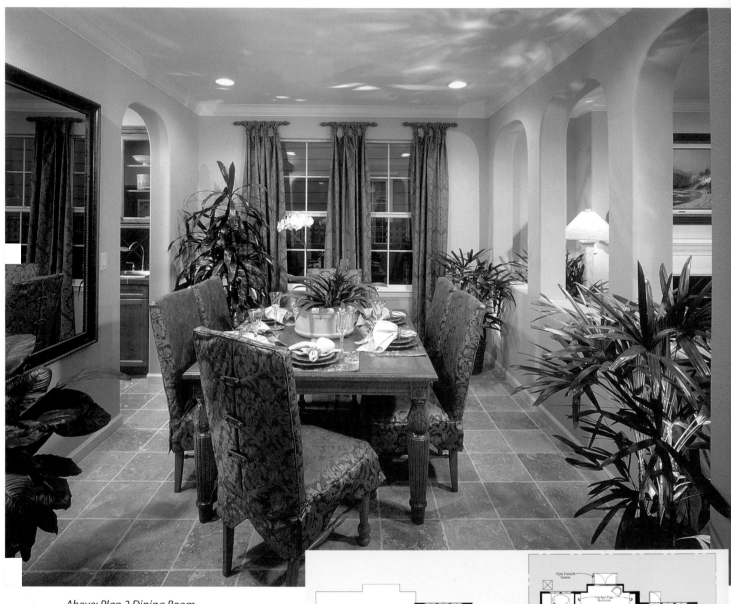

Above: Plan 2 Dining Room
Right: Plan 2 Floor Plans
The Village at Hiddenbrooke
Taylor Woodrow Homes
William Hezmalhalch Architects Inc.
Photo: John Bare Photography

Second Level

The Everett
Plan 2A - Arts & Crafts
2,634 Total Square Feet
4 Bdrm/3 Bath/2 Car Garage

First Level

50' x 80' Lot (Typ.)

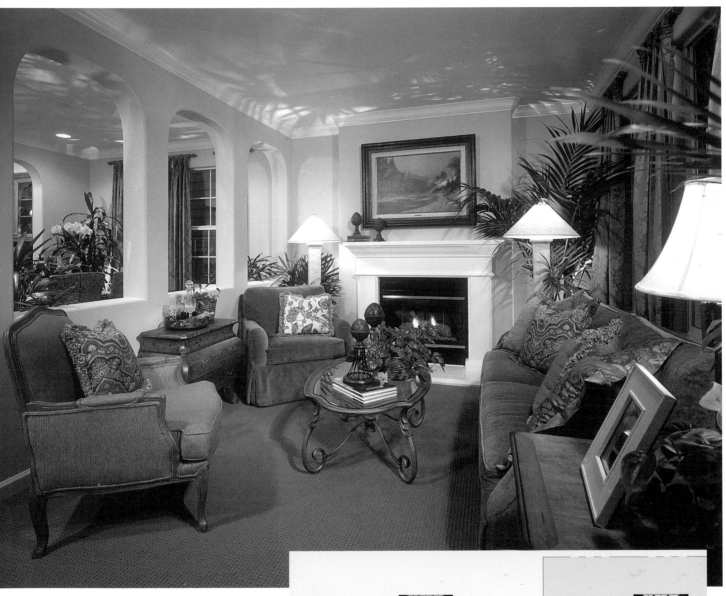

Above: Plan 2 Family Room
Right: Plan 3 Floor Plans
The Village at Hiddenbrooke
Taylor Woodrow Homes
William Hezmalhalch Architects Inc.
Photo: John Bare Photography

The Merritt
Plan 3D - Cottage
2,433 Total Square Feet
3 Bdrm/3 Bath/2 Car Garage

Second Level

First Level

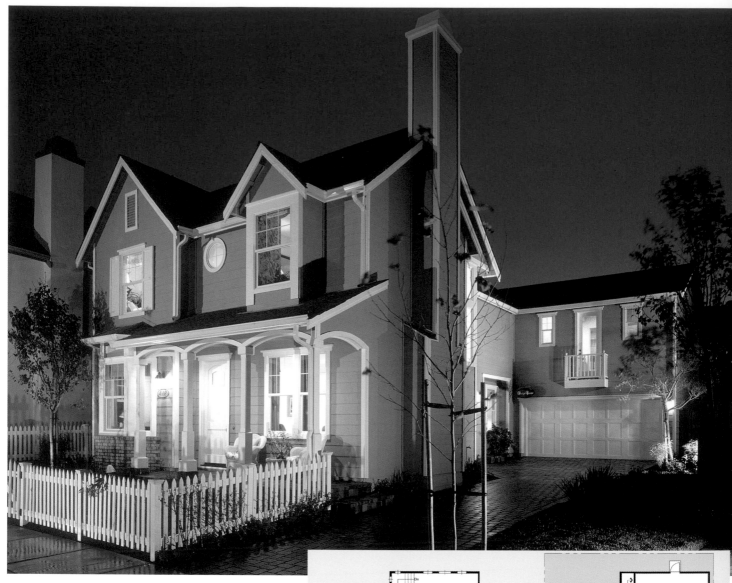

Above: Plan 4 Exterior
Right: Plan 4 Floor Plans
The Village at Hiddenbrooke
Taylor Woodrow Homes
William Hezmalhalch Architects Inc.
Photo: John Bare Photography

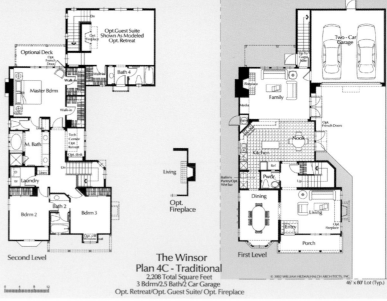

The Winsor
Plan 4C - Traditional
2,208 Total Square Feet
3 Bdrm/2.5 Bath/2 Car Garage
Opt. Retreat/Opt. Guest Suite/ Opt. Fireplace

Site Tabulation

Gross Area	17.9 Ac.
Number of Units	101
Net Density	5.64 Du/Ac.

Project Entry
Enhanced Community Entrance
Provides Garden Cottage Appeal
For Community Identity
Including Tollhouses at The
Entry Gates, Enhanced Paving,
Pedestrian Friendly Street Scenes

Sales Office

Model Complex

Architectural Massing at Golf Course

Golf Course

Corner Lot Plotting Provides Four Sided Architecture

Community Sundial

Open Space

Open Space Fencing at Golf Course

Golf Course

Linear Park Connects Pedestrians Through Neighborhood

Cart Path

Focal Trees Provide Street Breakup

Cart Path

Open Space

Tiered Site For Golf Course View Opportunities

Access to Golf Clubhouse

Club House

Front Setbacks Provide Varied Streetscene

North

P3
Typ. Lot Size 46' X 80'

P1 & P2
Typ. Lot Size 50' X 80'

P4
Typ. Lot Size 46' X 80'

© 2003 WILLIAM HEZMALHALCH ARCHITECTS, INC.

Site Plan
The Village at Hiddenbrooke
Taylor Woodrow Homes
William Hezmalhalch Architects Inc.

View of Hiddenbrooke Homes
Photo courtesy Kate Fowle

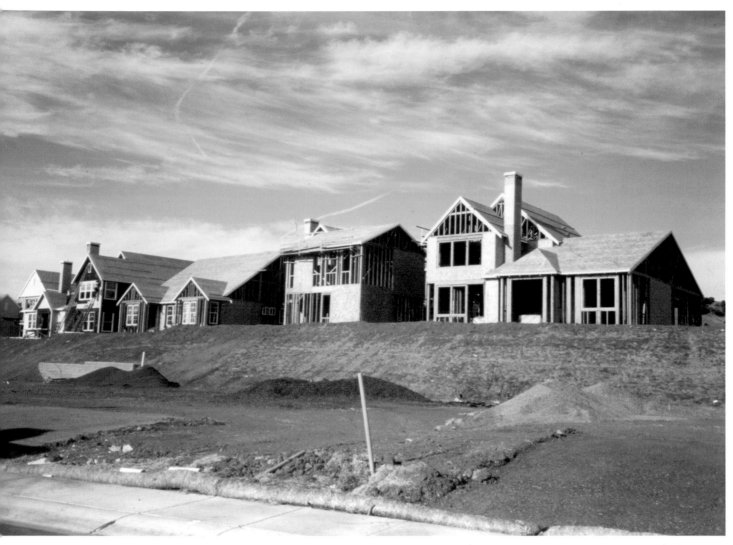

Hiddenbrooke during Construction
Photo courtesy Kate Fowle

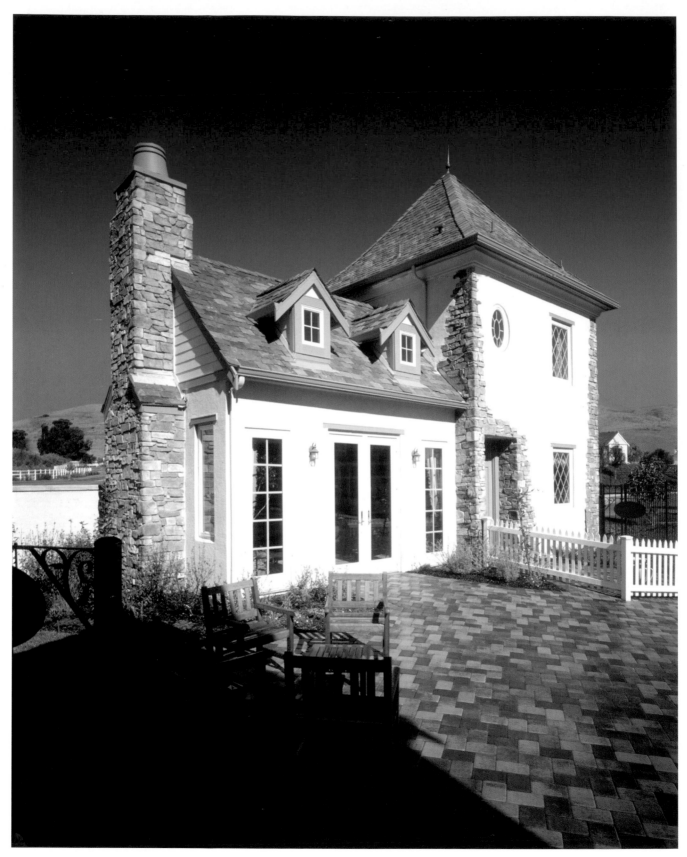

Tollhouse Exterior
The Village at Hiddenbrooke
Taylor Woodrow Homes
William Hezmalhalch Architects Inc.
Photo: John Bare Photography

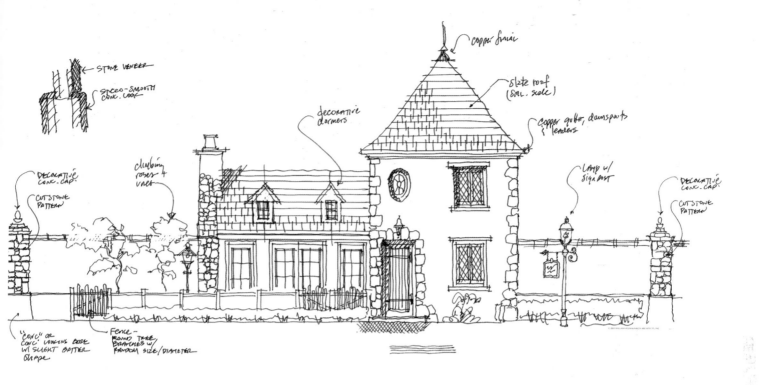

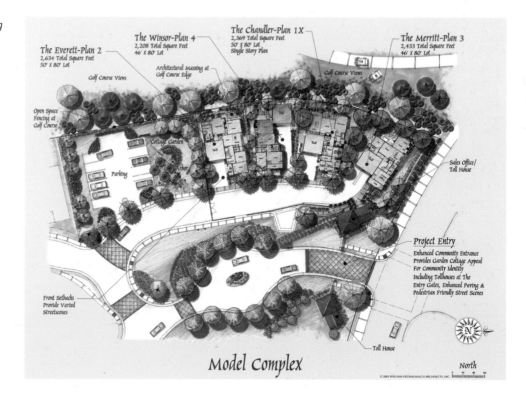

Above: Tollhouse Inspirational Drawing
Right: Model Complex
The Village at Hiddenbrooke
Taylor Woodrow Homes
William Hezmalhalch Architects Inc.

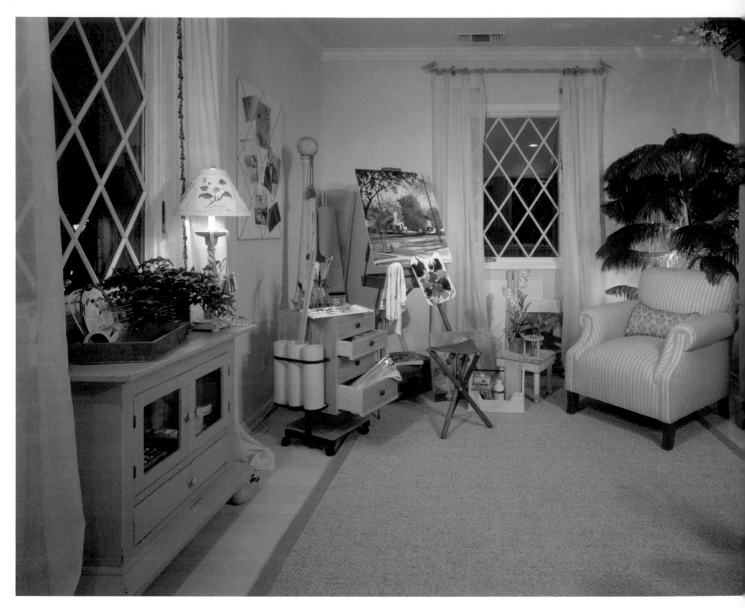

Tollhouse Hobby Room
The Village at Hiddenbrooke
Taylor Woodrow Homes
William Hezmalhalch Architects Inc.
Photo: John Bare Photography

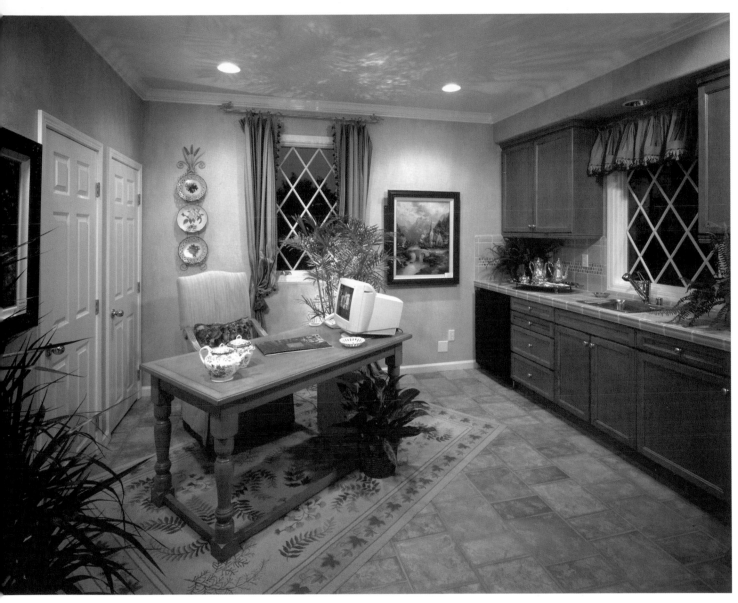

Tollhouse Kitchen
The Village at Hiddenbrooke
Taylor Woodrow Homes
William Hezmalhalch Architects Inc.
Photo: John Bare Photography

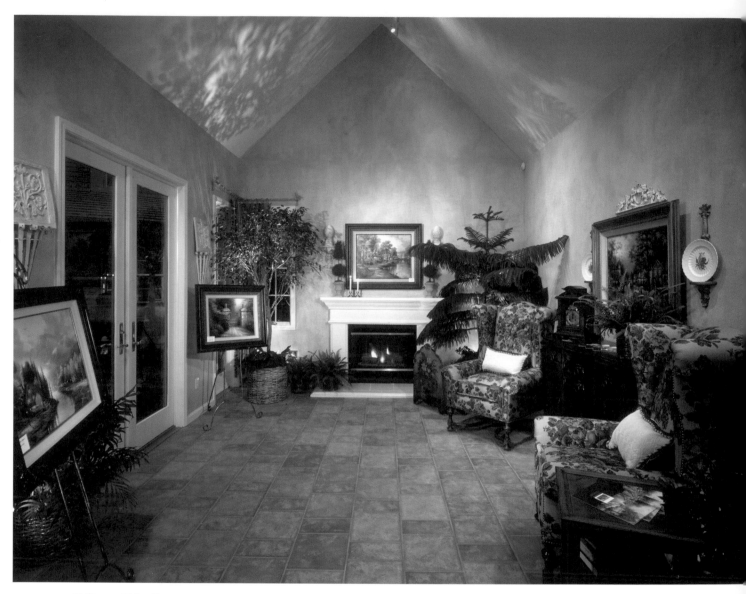

Tollhouse Living Room
The Village at Hiddenbrooke
Taylor Woodrow Homes
William Hezmalhalch Architects Inc.
Photo: John Bare Photography

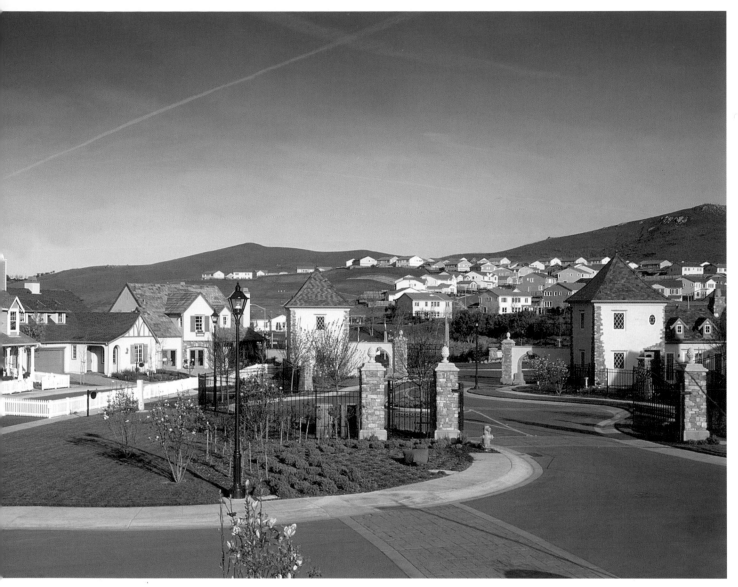

Entrance to the Village at Hiddenbrooke
Photo courtesty of Kate Fowle

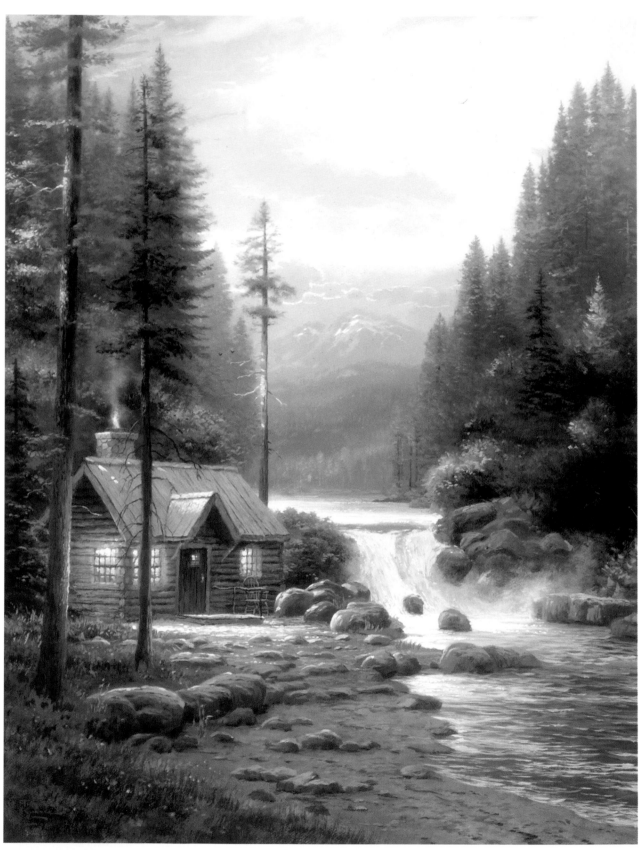

Evening in the Forest
Hearthstone Homes
www.hearthstonehomes.com
Thomas Kinkade original painting used as
inspiration for log cabin designs.

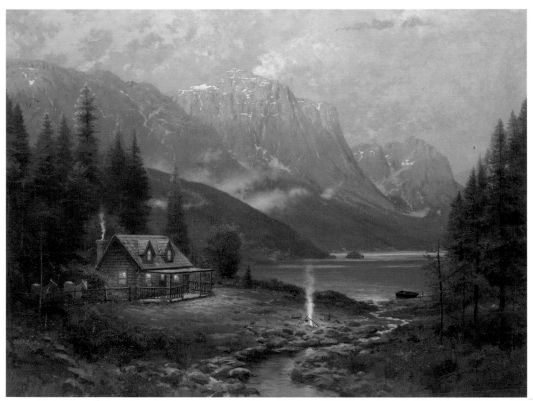

Beginning of a Perfect Day
Hearthstone Homes
www.hearthstonehomes.com
Thomas Kinkade original painting used as
inspiration for log cabin designs.

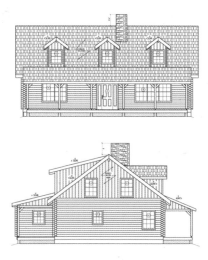

Log cabin elevations
Hearthstone Homes
www.hearthstonehomes.com

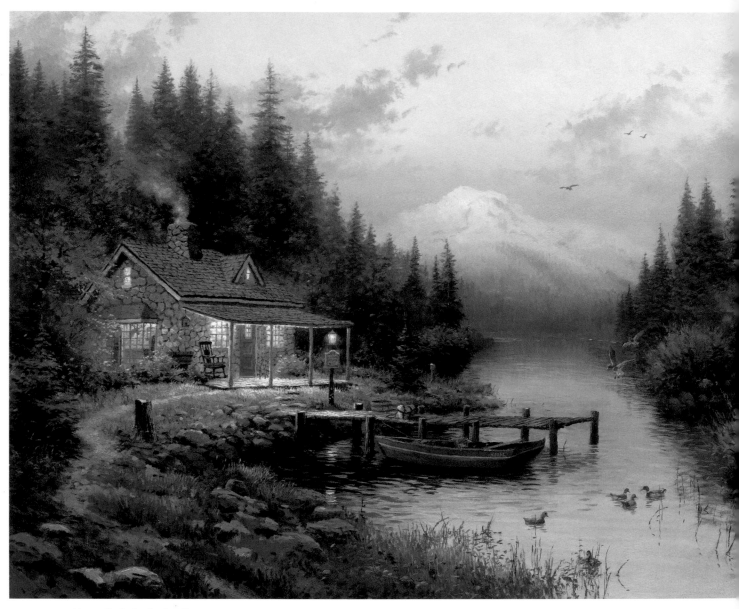

Above: End of a Perfect Day
Right: Log cabin floor plan
Hearthstone Homes
www.hearthstonehomes.com
Thomas Kinkade original painting used as
inspiration for log cabin designs.

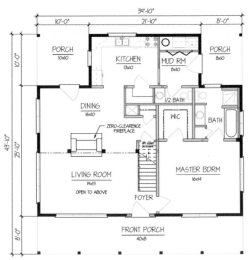

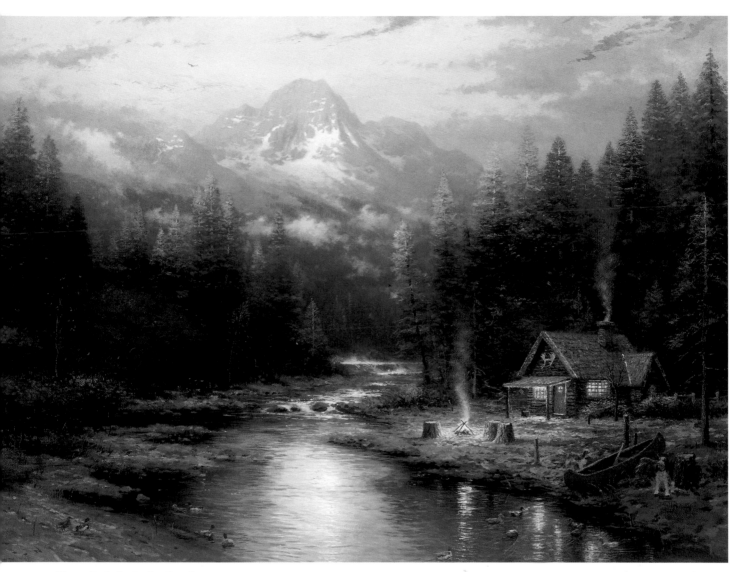

Above: End of a Perfect Day II
Right: Log cabin floor plan
Hearthstone Homes
www.hearthstonehomes.com
Thomas Kinkade original painting used as
inspiration for log cabin designs.

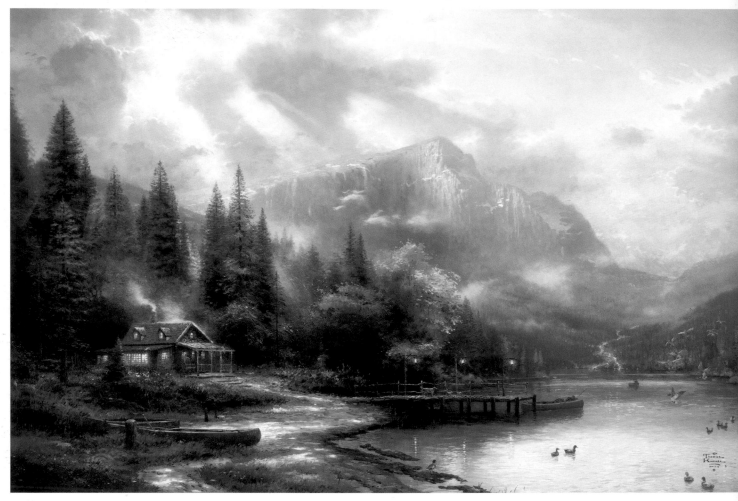

End of a Perfect Day III
Hearthstone Homes
www.hearthstonehomes.com
Thomas Kinkade original painting used as
inspiration for log cabin designs.

A Time For Every Season
Wall clock with four scenes
Gallery Marketing Group Inc.
www.gallerymarketinggroup.com

THOMAS KINKADE

INSPIRED LIVING

Fabric Sample Book
Thomas Kinkade Collection
Bloomcraft Fabrics

142

Thomas Kinkade Collection
Fabric swatches
Bloomcraft Fabrics

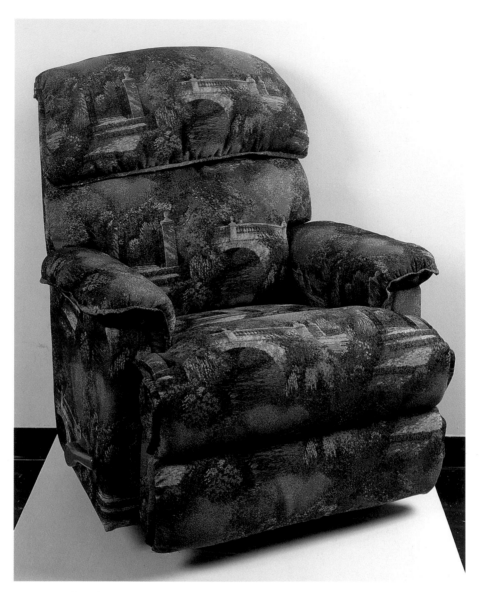

La Z Boy Bridge of Faith Chair
Rocker-Recliner
La Z Boy Inc.
www.lazyboy.com
Photo: M.O. Quinn

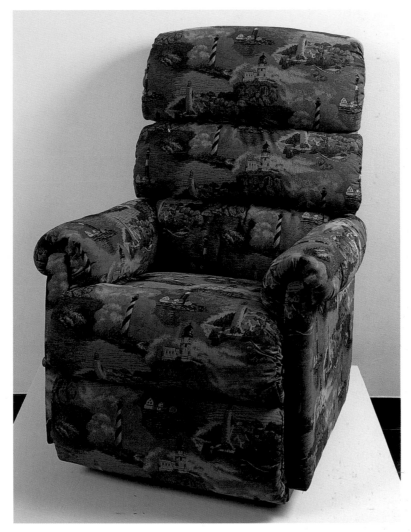

La Z Boy Lighthouse Chair
Rocker-Recliner
La Z Boy Inc.
www.lazyboy.com
Photo: M.O. Quinn

Wallpaper Design
Bedroom scene
Thomas Kinkade Painter of Light Volume 2
Imperial Wall Décor
© Imperial
www.ihdg.com

Hidden Cottage
Woven wall hanging
Mohawk Homes Goodwin Weavers Collection
www.goodwinweavers.com

The Garden of Prayer
Tiffany style Thomas Kinkade table lamp
Splendor Lighting
www.splendor.com

A Peaceful Time and *Chandler's Cottage*
Reversed hand painted Thomas Kinkade table lamps
Splendor Lighting
www.splendor.com

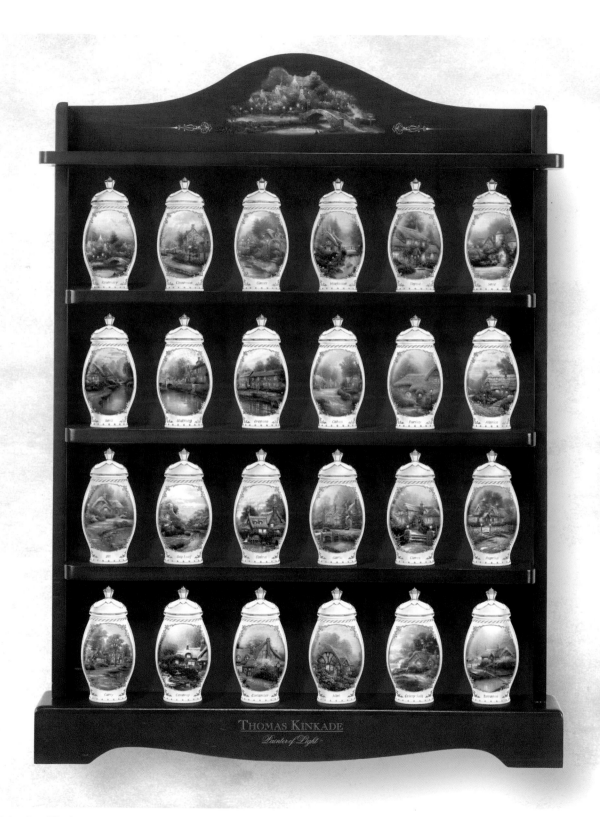

Spice Jars Display
Gallery Marketing Group Inc.
www.gallerymarketinggroup.com

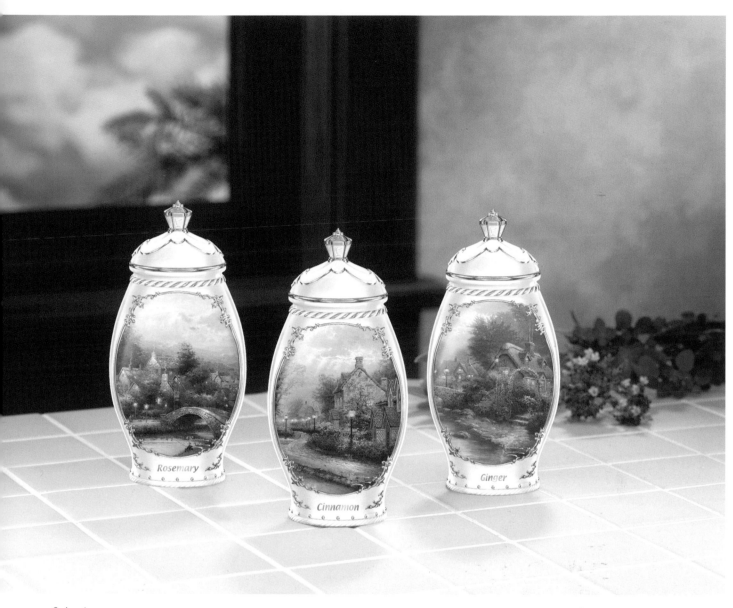

Spice Jars
White china
Gallery Marketing Group Inc.
www.gallerymarketinggroup.com

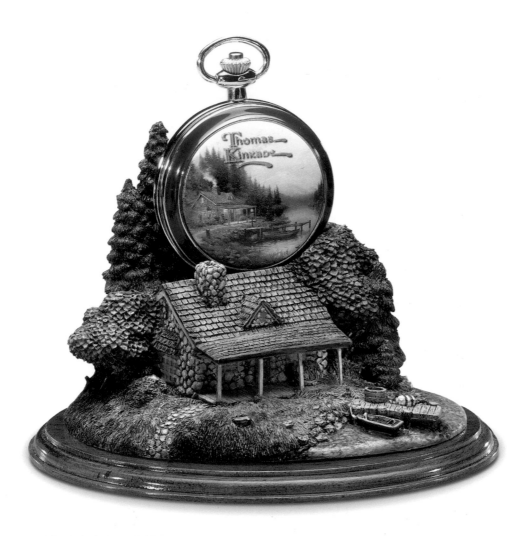

The End of a Peaceful Day
Pocket watch with display
Gallery Marketing Group Inc.
www.gallerymarketinggroup.com

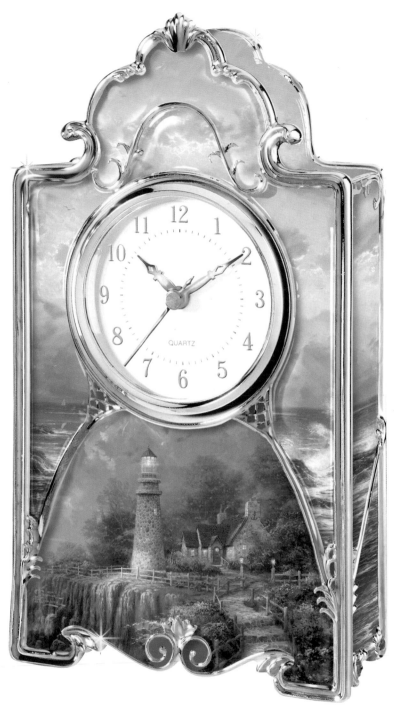

Moments at the Shore Clock
The Light of Peace image on mantel clock
Gallery Marketing Group Inc.
www.gallerymarketinggroup.com

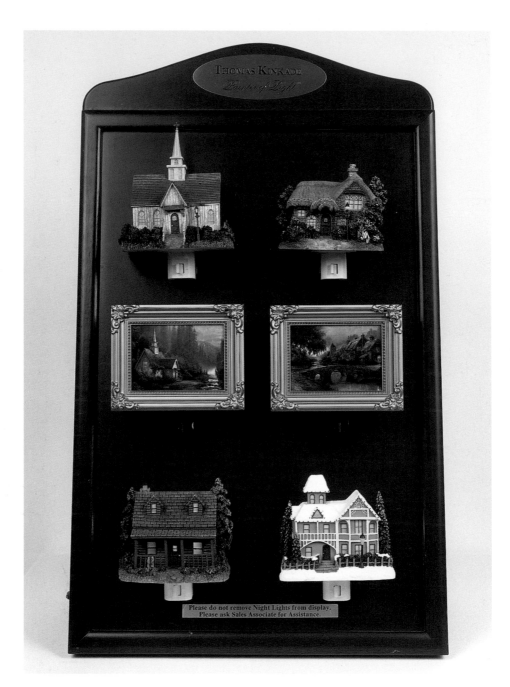

Nightlights
Six decorative nightlights in store display
The Thomas Kinkade Company
(formerly Media Arts Group Inc.)
www.thomaskinkade.com
Courtesy of Village Gallery, Santa Ana, California
Photo: M.O. Quinn

Beacon of Hope Lighthouse Salt and Pepper Shakers
Crafted of ivory china and accented with 24 karat gold
Lenox Inc.
www.lenox.com

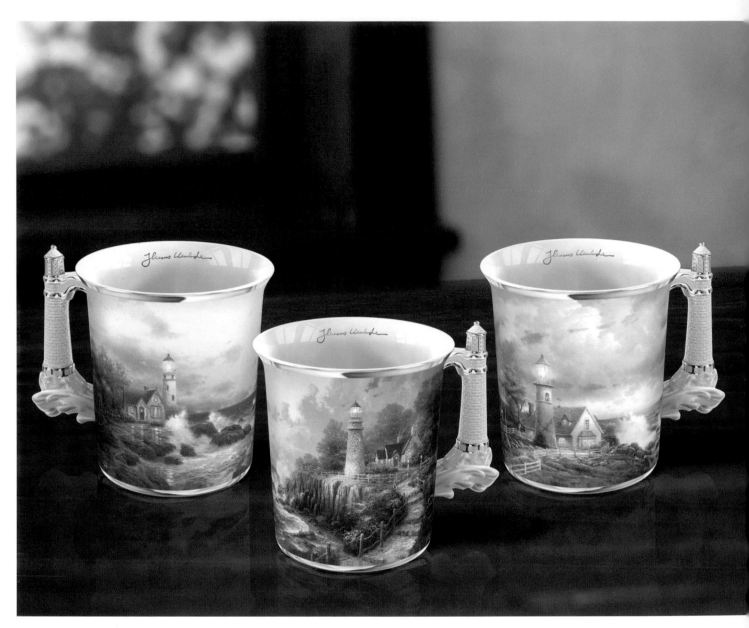

Seaside Mug Collection
Three china mugs
Gallery Marketing Group Inc.
www.gallerymarketinggroup.com

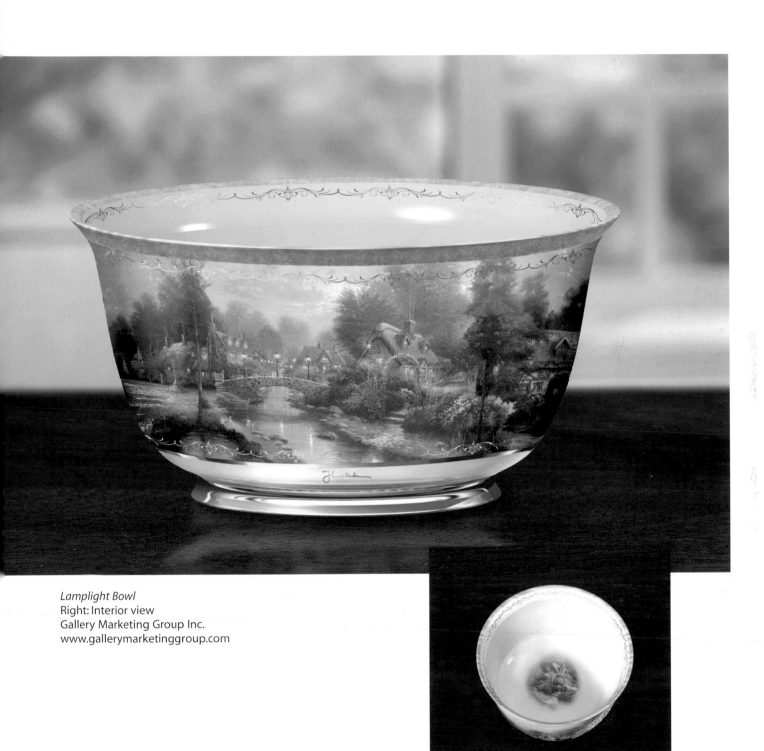

Lamplight Bowl
Right: Interior view
Gallery Marketing Group Inc.
www.gallerymarketinggroup.com

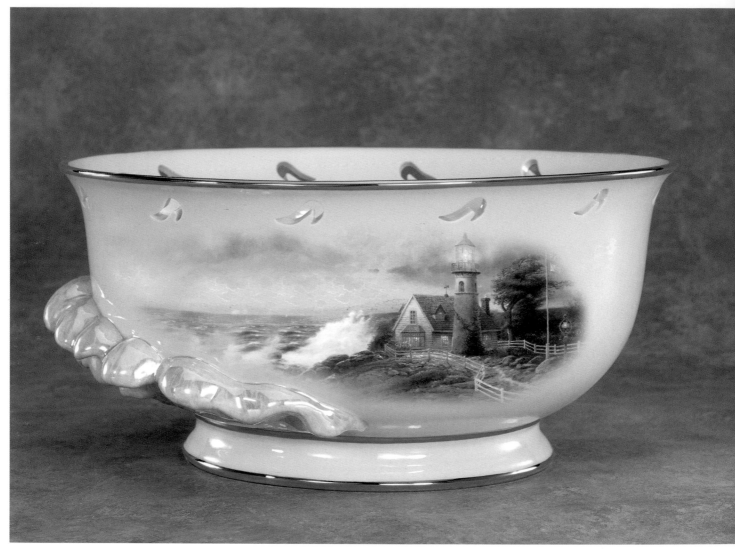

A Light in the Storm Lighthouse Bowl
Crafted of ivory china and accented
with 24 karat gold
Lenox Inc.
www.lenox.com

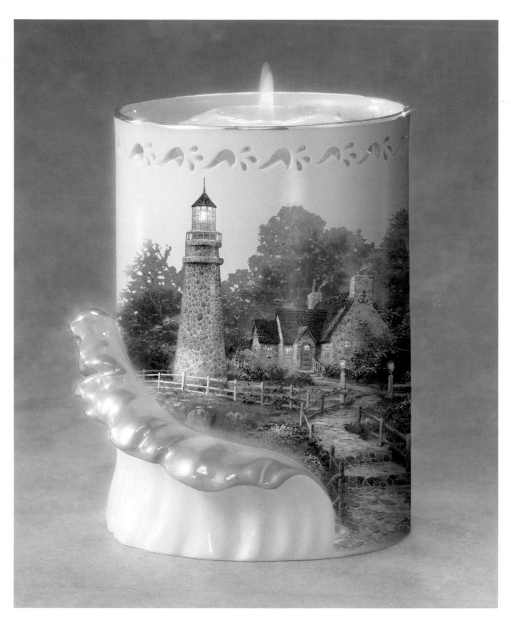

Light of Peace Votive
Crafted of ivory china and accented
with 24 karat gold
Lenox Inc.
www.lenox.com

Everyday Light Planner
Thomas Nelson Inc.
www.thomasnelson.com

Above: The Spirit of America
Left: Garden of Friendship
Thomas Nelson Inc.
www.thomasnelson.com

Mealtime Memories
Sharing the Warmth of Family Tradition
Thomas Nelson Inc.
www.thomasnelson.com

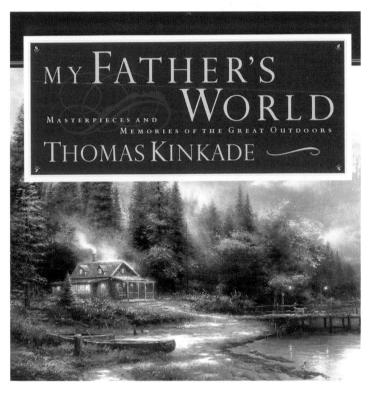

Above: My Father's World
Left: The Home You Made for Me
Thomas Nelson Inc.
www.thomasnelson.com

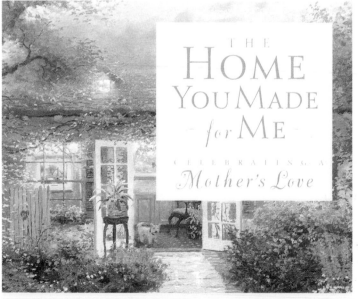

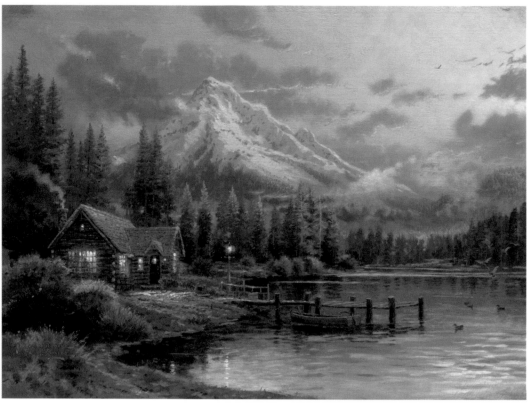

Lakeside Hideaway, 1999
Lakeside Hideaway Series
Oil on canvas, 12 x 16
Collection of Thomas Kinkade
Courtesy of the Thomas Kinkade Museum
and The Thomas Kinkade Company
Published: March 1999

Mount Hood in Oregon inspired Thom to paint this work. It features a secluded cabin along a peaceful lake in a majestic mountain area—a perfect place for someone to rest and relax. Thom said, "This painting suggests in my heart a profound truth; I had the sense as I worked that the canvas painted itself. Perhaps our lives should be lived with just such selfless ease and grace."

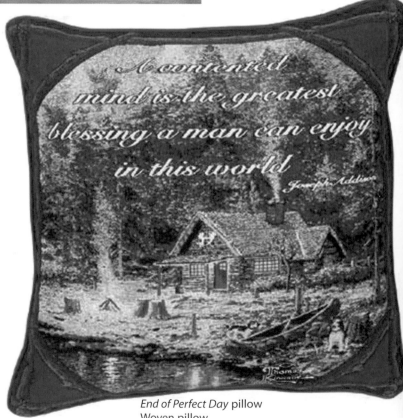

End of Perfect Day pillow
Woven pillow
Mohawk Homes Goodwin Weavers Collection
www.goodwinweavers.com

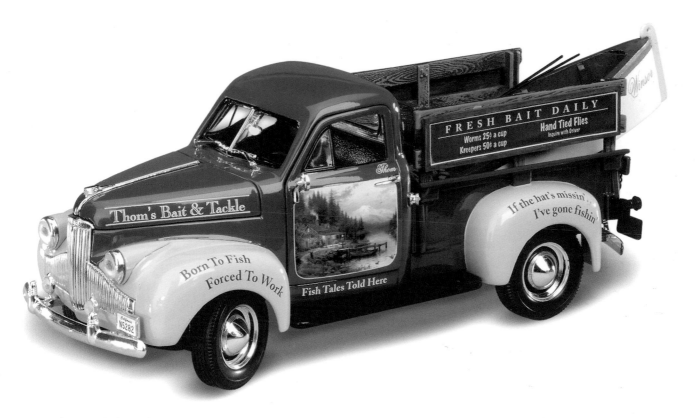

Above: End of a Perfect Day Truck
Below: Deer Creek Farms Tractor Trailer
Die cast trucks
Gallery Marketing Group Inc.
www.gallerymarketinggroup.com

Make A Wish Foundation—After visiting 14 cities across the country as part of his 20 Years of Light Tour, Thomas Kinkade, the Painter of Light™, has successfully raised more than $100,000 exclusively for the Make-A-Wish Foundation®, an organization which grants the wishes of terminally ill children. During the tour, which celebrated his twentieth year as a published artist, Mr. Kinkade also met with individual Make-A-Wish children in select cities to share his skills as an artist with those whose wish was to learn how to draw. Mr. Kinkade raised money for the Foundation by auctioning a Limited Edition canvas at each tour stop with an original hand-drawn sketch by Mr. Kinkade on the back of each canvas to make it unique. As a national spokesperson for the Foundation, Kinkade hopes his efforts will raise awareness of the organization and work towards granting the hopes, dreams, and wishes of more Make-A-Wish children.

"This experience has impacted me deeply. I feel honored to have been chosen as a national spokesman for this foundation and hope to give to these courageous Make-A-Wish children as much as I can possibly offer. They are an inspiration to us all," Kinkade said.

Thomas Kinkade presents a $100,000 check to Sue Petersen (executive director of the Giants Community Fund) and Vida Blue (pitcher for the San Francisco Giants from 1978-81, 85-86) on July 26, 2003. The Giants Community Fund's mission is to use baseball as a forum to encourage youngsters and families to live healthy, productive lives. The Fund supports Junior Giants summer leagues and other assistance in needycommunities.

Kinkade supports Giants charity—Thomas Kinkade signed his name about a thousand times at KNBR/Giants Summer FanFest. The last item he autographed was undoubtedly the most satisfying, as Kinkade—known as the "Painter of Light" and the country's most collected living artist—signed a check to the Giants Community Fund for an impressive $100,000.

Kinkade, the official artist of the 2002 World Series, donated 5,000 prints of a painting he made during Game 3 of the Fall Classic at Pacific Bell and came to the FanFest to sign some of those prints. The line of people waiting to purchase the poster, entitled *A Night at the Park,* easily outdistanced any other queue at the FanFest as fans waited to meet the artist and get their prints autographed.

"I'm all about empowering kids," he said. "If you can get kids out of a violent lifestyle or out of a dead-end lifestyle and give them a chance to have self-esteem through sports, through the arts, through music, through anything, I'm all for it. It's a natural alliance and I'm proud to be involved with it."

Thomas Kinkade to Donate Proceeds from Special Edition Prints to The Salvation Army—The Salvation Army announced that Thomas Kinkade, America's most distinguished contemporary painter, has created two special edition works of art to benefit The Salvation Army. One, a vignette of the New York skyline post-September 11, 2001, has already generated $1,000,000 dollars for Salvation Army disaster relief efforts through the generosity of Kinkade who donated 100 percent of his sale proceeds.

Kinkade Family Holistic Center Benefits Community—The construction of the first phase of the Kinkade Family Holistic Center, funded by the Thomas Kinkade Foundation, was inaugurated. The center will be of benefit to around 3200 sponsored children and their families from ADP Cetrepsa (GTM-168220 supported by World Vision United States) located in the state of Jaliapa, 114 kms east of Guatemala City.

"Thanks to World Vision and the Thomas Kinkade Foundation for the construction of this center," said Carlos Hernandez Crispin, President of the ADP committee.

Thomas Kinkade Foundation donates 10,000 posters—Thomas Kinkade was selected as the Official Artist for *Let Freedom Run*, a one-time-only race to honor and remember the victims of the September 11th, 2001 attacks. Kinkade was selected as the official artist by the Mayor of New York City, sponsor of this one-time event.

"I am honored to be a part of this event. While my painting is entitled *The Light of Freedom,* Americans are the true lights of freedom," Kinkade said after being asked to participate in the event. "As a tribute to those who lost their lives on September 11th, together we will remember and honor them as we celebrate the spirit of America," Kinkade added.

Thomas Kinkade and two members from Encourage America presented a lithograph of "The Light of Freedom" to New York Firefighters on December 17, 2001.

Archbishop Mitty High School—With award-winning performance groups and one of the top performing arts teaching staffs in the San Francisco Bay Area, Archbishop Mitty High School has become a magnet for aspiring artists. Over 300 students participate in the performing arts program each school year. In April of 2003 guests began to enjoy a variety of student performances in the new 370 seat Thomas Kinkade Center for the Performing Arts.

Food Bank of El Dorado County—In 2003 the Thomas Kinkade Foundation donated $20,000 to the Food Bank of El Dorado County to fight local hunger. The food bank assists over 8,000 less fortunate children, senior citizens and families throughout El Dorado County. The Food Bank collaborates with over 35 non-profit organizations such as food pantries, food kitchens, children's programs, maternity homes, etc. to provide a safety net for the needy of El Dorado County on a daily basis.

Artist Thomas Kinkade Awarded Prestigious World Children's Center Humanitarian Award—On Saturday, August 10, 2002 at the World Children's Center Fifth Annual Gala and Benefit Concert, world-renowned artist Thomas Kinkade was awarded the World Children's Center Humanitarian Award. The World Children's Center Humanitarian Award recognizes regional, national or international businesses and individuals who are making an extraordinary contribution toward improving the welfare of children and their families.

Harris County (Georgia) schools win Thomas Kinkade's Art for Children's Charities first educational grant—Three Harris County schools each received three $1,000 grants from the newly formed Art for Children Charities. New Mountain Hill Elementary, Park Elementary, and Pine Ridge Elementary will participate in a unique program where resident artists will visit the schools three days a week during the 2001–2002 school year. The artists will share many enriching experiences including their training and how art has impacted their lives and the lives of others. The students will also work on completing projects related to each artist's respective area of expertise.

"The World Children's Center is extremely proud to be affiliated with Art for Children through our strong relationship with world-renowned artist Thomas Kinkade," said Founder, President and CEO Don Whitney. "Thom, who serves on the Center's Advisory Board, wholeheartedly supports our commitment to supporting the surrounding community in which the World Children's Center will be built."

Above: *Drawing Excitement with Thomas Kinkade* video
Courtesy of Kolorful Kids
www.kolorfulkids.org

Right: *Sharing the Light with One More Child*
The Thomas Kinkade Company
www.thomaskinkade.com

CALIFORNIA STATE UNIVERSITY FULLERTON

GRAND CENTRAL ART CENTER
Andrea Lee Harris, Dennis Cubbage, Amy Caterina-Barrett, Rebecca C. Banghart, Scott Stodder,
David Michael Lee, Eric Jones, Scott Hilton, Linda Sears, Brett Caterina-Barrett and Frank Swann.

GRAND CENTRAL ART FORUM
Greg Escalate, Shelley Liberto, Mitchell De Jarnett, Marcus Bastida, Teri Brudnak,
Lisa Calderone, Don Cribb, Jon Gothold, John Gunnin, Mary Ellen Houseal, Dennis Lluy, Mike McGee,
Stuart Spence, Ren Messer, Advisory Members: Peter Alexander, Rose Apodaca Jones, Kristin Escalante,
Mike Salisbury, Anton Segerstrom and Paul Zaloom

CALIFORNIA STATE UNIVERSITY FULLERTON
Milton A. Gordon, President; Jerry Samuelson, Dean, College of the Arts; Larry Johnson, Chair, Department of Art;
Bill Dickerson, Executive Director, CSUF Foundation; Mike McGee, Marilyn Moore, Martin Lorigan,
Edgar M. Tellez, Jason Chakravarty and the CSUF Art Alliance

Exhibition Design Students: Janice Christmas, Dennis Cubbage, Maria-Lisa Flemington,
Carlos Herrera, Julie Perlin, Cheryl Schriefer, Ann Bradley, Christina Hasenberg, Jenny Kimber,
Milka Marinov, Hilary Polk, Beth Solomon, Kristin Brazell, Tina Chang, Carlota Haider,
Solyi Han, Beatriz Nevarez, Lindsay Olson, Robin Provart-Kelly, Joanne Sterling and Gregory Whittaker.

This edition was published by Last Gasp of San Francisco and California State University, Fullerton,
Grand Central Art Center and Main Art Gallery in conjunction with the exhibition *Thomas Kinkade Heaven On Earth,*
Jeffrey Vallance, curator, at California State University, Fullerton, Grand Central Art Center, Santa Ana, California
and Main Art Gallery, Fullerton, California, 3 April–20 June, 2004.

The exhibition and catalog were made possible by the generous support of the Grand Central Art Forum;
Cal State University Fullerton Grand Central Art Center; Main Art Gallery and Last Gasp of San Francisco.

Editors: Sue Henger and Marilyn Moore
Designer: Debora Brown
Photography: M.O. Quinn, Kate Fowle, John Bare Photography, Design Lens.com
Unless otherwise noted, all photographs are courtesy of The Thomas Kinkade Company
Printed by: Prolong Press LTD, Hong Kong

LAST GASP
777 Florida Street
San Francisco, California 94110
415 - 824-6636
www.lastgasp.com

GRAND CENTRAL PRESS
CSUF Grand Central Art Center
125 N. Broadway, Suite A
Santa Ana, California 92701
714-567-7233 714-567-7234
www.grandcentralartcenter.com

International Standard Book Number: 0-86719-613-0

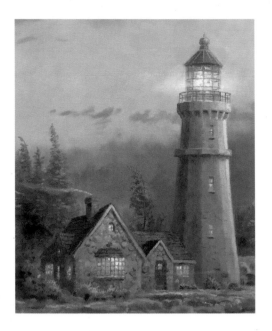

Detail from Conquering the Storm